First published in 2017 by Modern Toss Ltd.
Modern Toss, PO Box 386, Brighton BN1 3SN, England
www.moderntoss.com

ISBN 978-0-9929107-4-7

A CIP catalogue record for this book is available from the British Library.

Designed and typeset by Modern Toss
Printed and bound by Newman Thomson

Visit www.moderntoss.com to read more about all our books and to buy them yeah.
You will also find lots of other shit there, and you can sign up to our mailing list so
that you're always kept bang up to date with it, cheers.

THE WEEKEND
colouring book

by Jon Link & Mick Bunnage

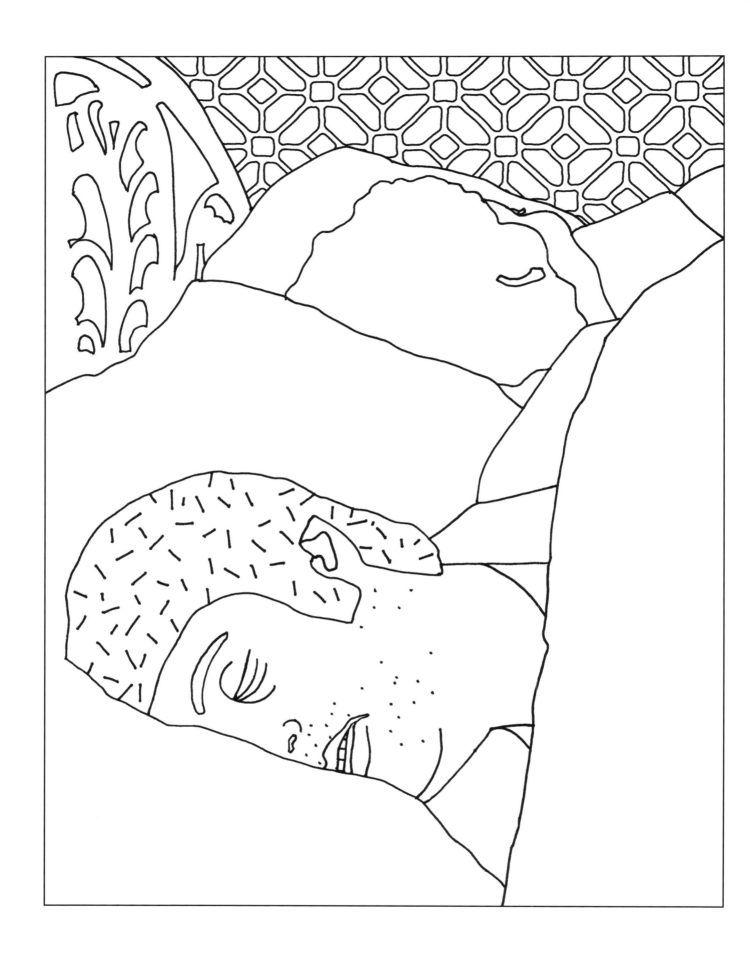

The weekend usually starts with me waking up.

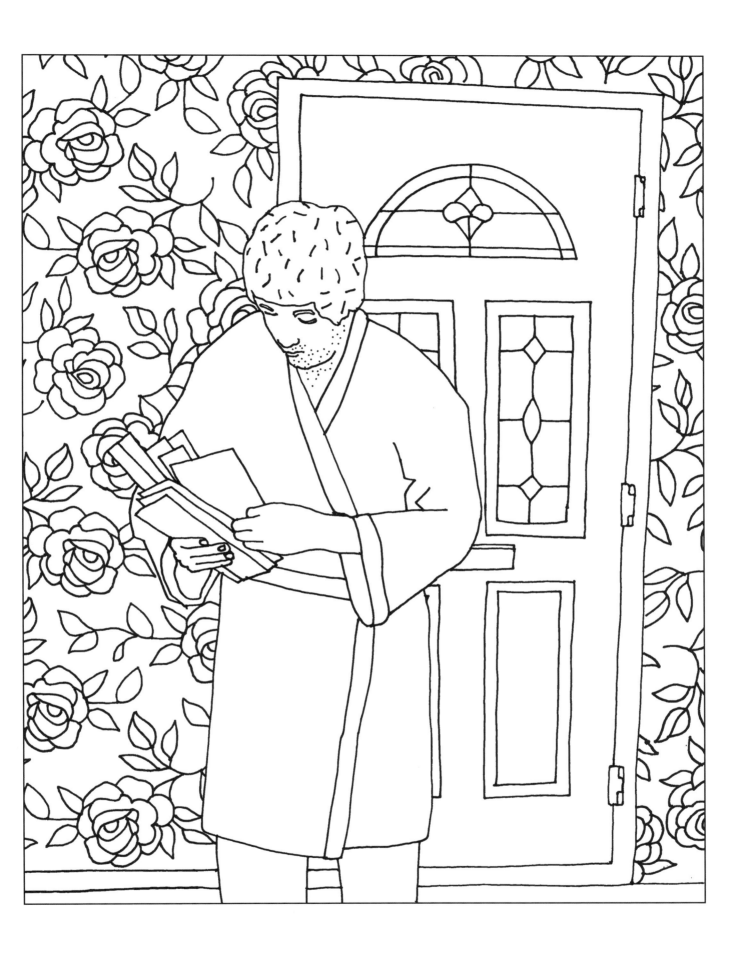

I like to check the morning post. Yeah, mostly shit.

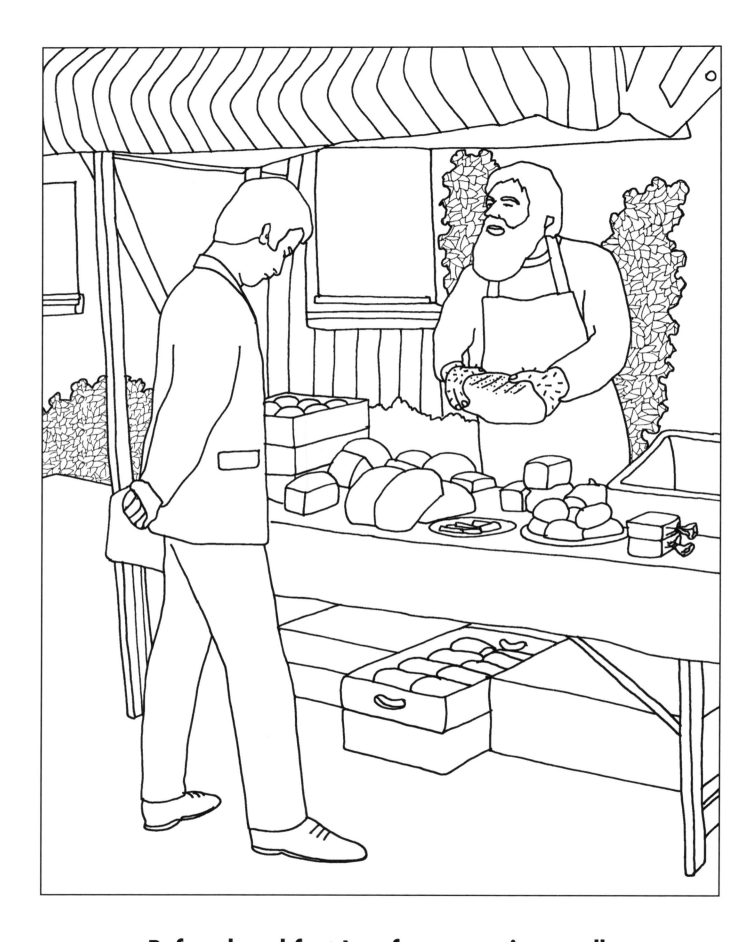

**Before breakfast I go for a morning stroll.
I might buy a charcoal-fired seeded loaf from
a pop up artisan bakery. I might not.**

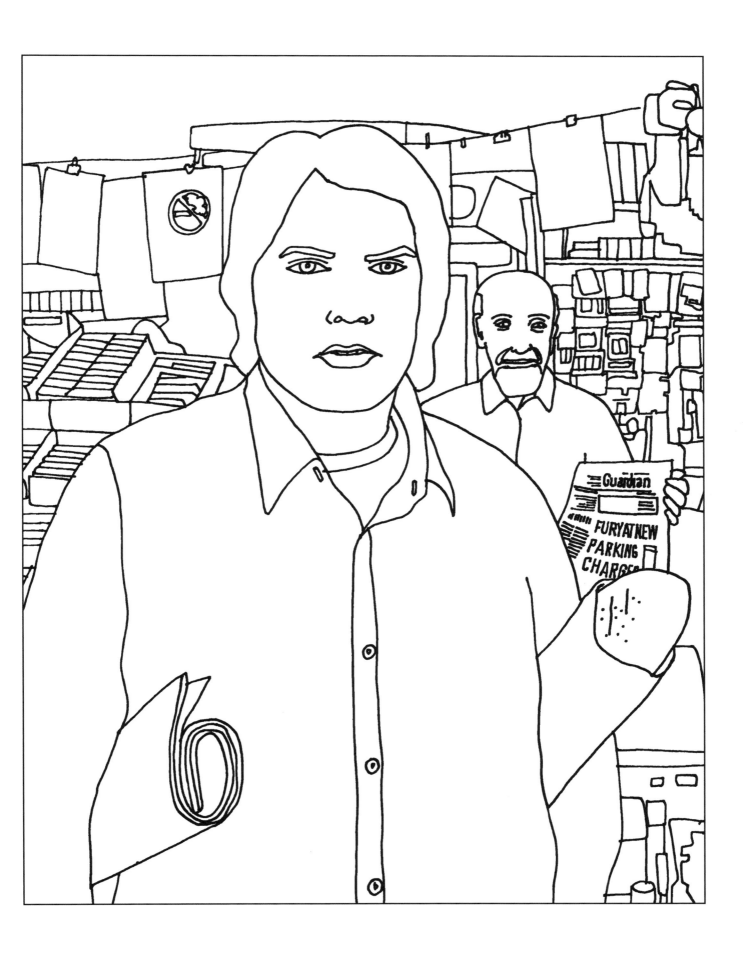

I'm not really interested in news. I buy a bulky paper to carry around instead of going to the gym.

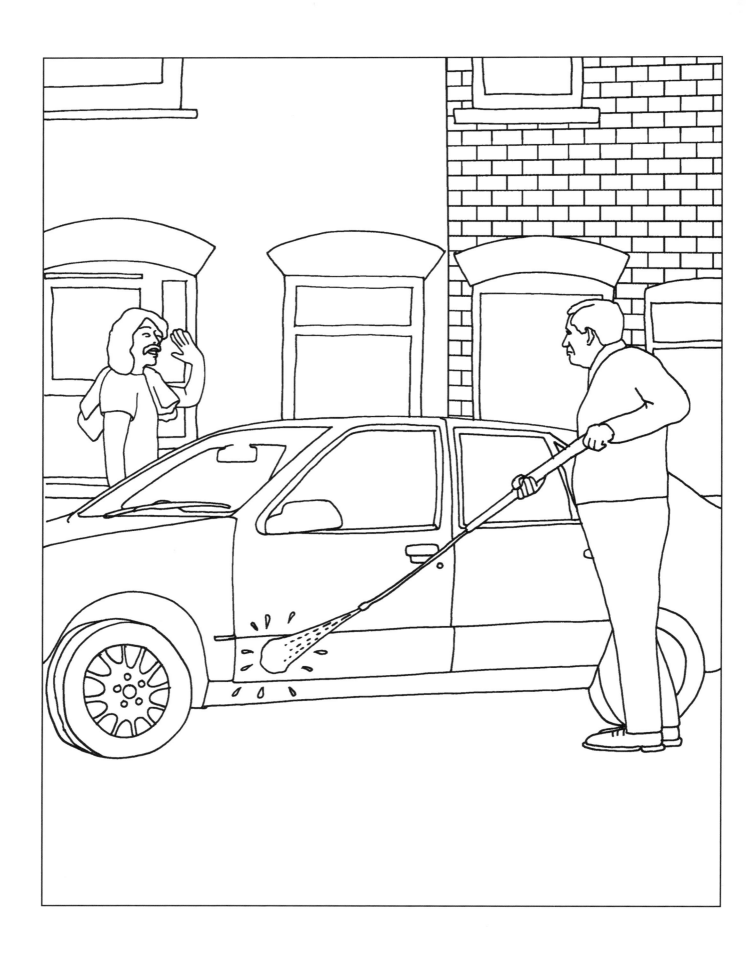

'Morning. Cleaning the car?'
'No, I'm wiping my arse with a brick.'

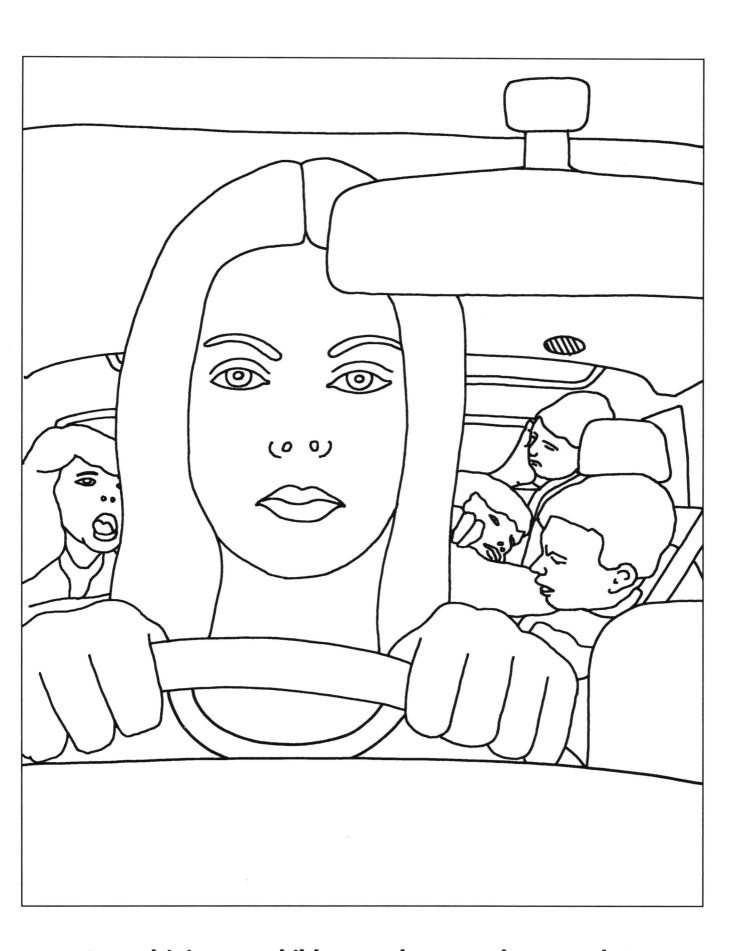

I am driving my children and some other people's children to a local swimming event. If I crash the car someone else will have to drive them back.

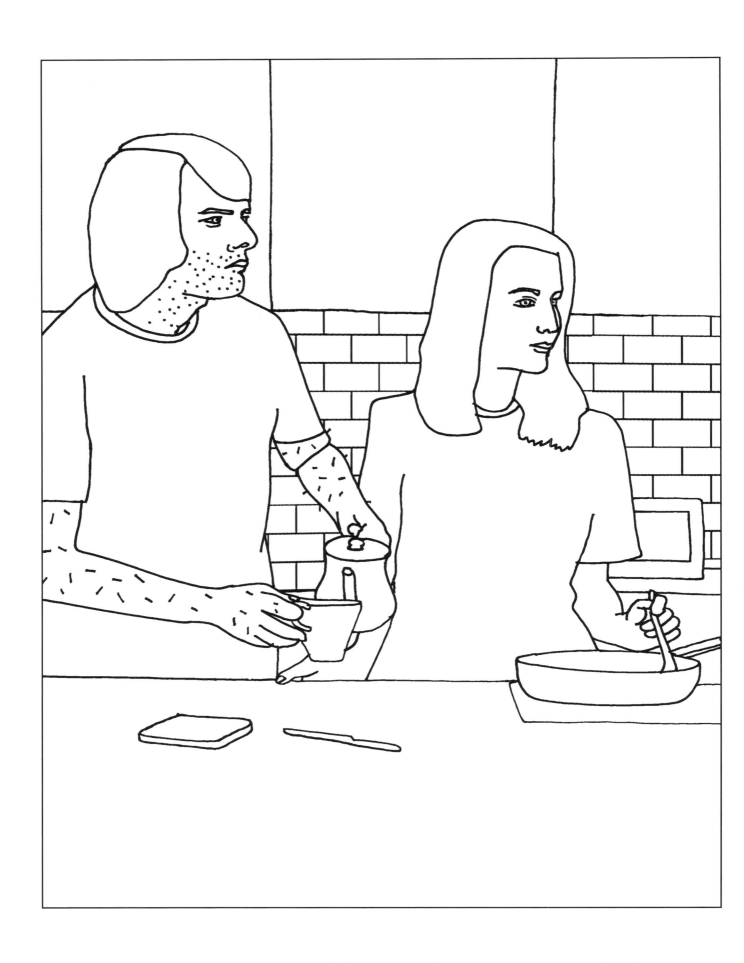

I eat some toast while watching some TV chefs make breakfast and chat shit with celebs.

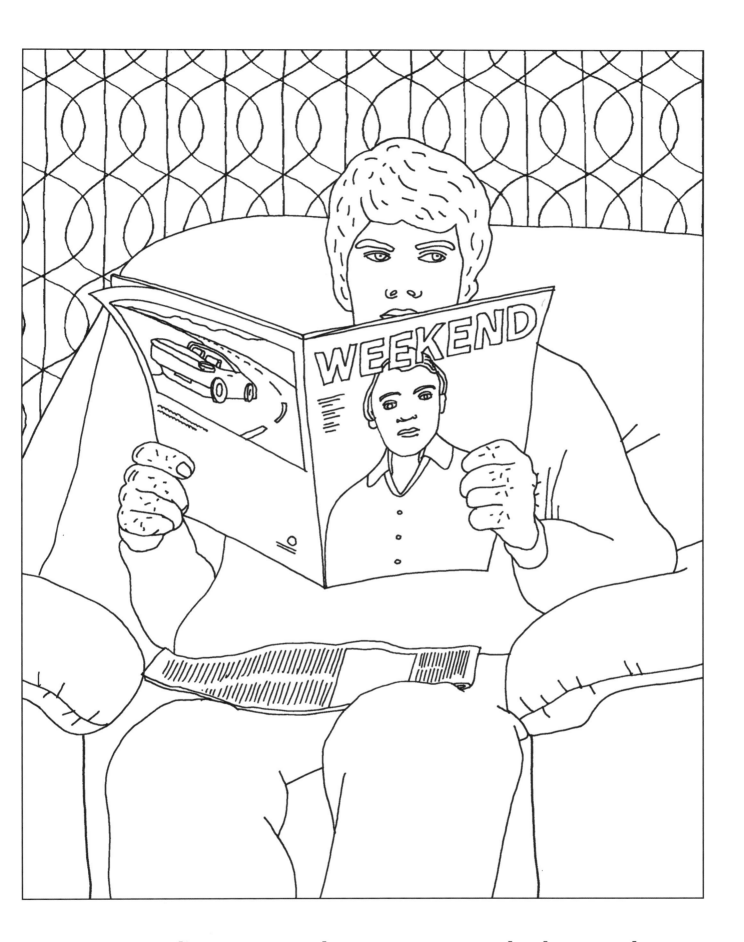

**I am reading a Q&A about someone who has made
a TV programme about a book they wrote. I see they like
to kick-start their day with a single source macchiato.**

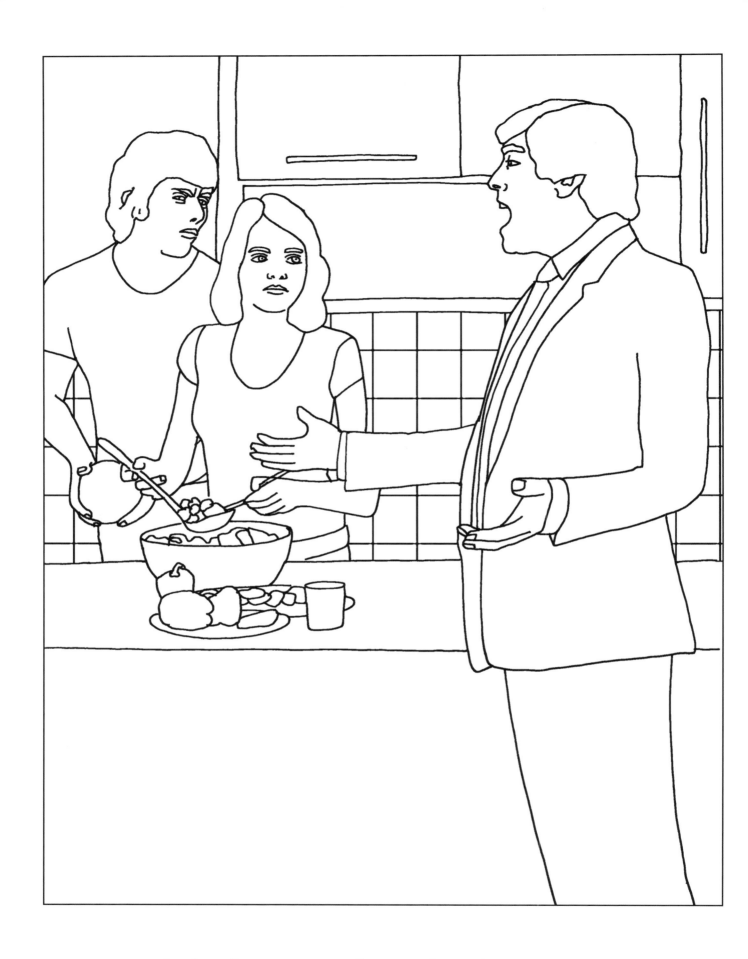

A relative has popped round to discuss a topical news event. Keep nodding, he'll fuck off in a bit.

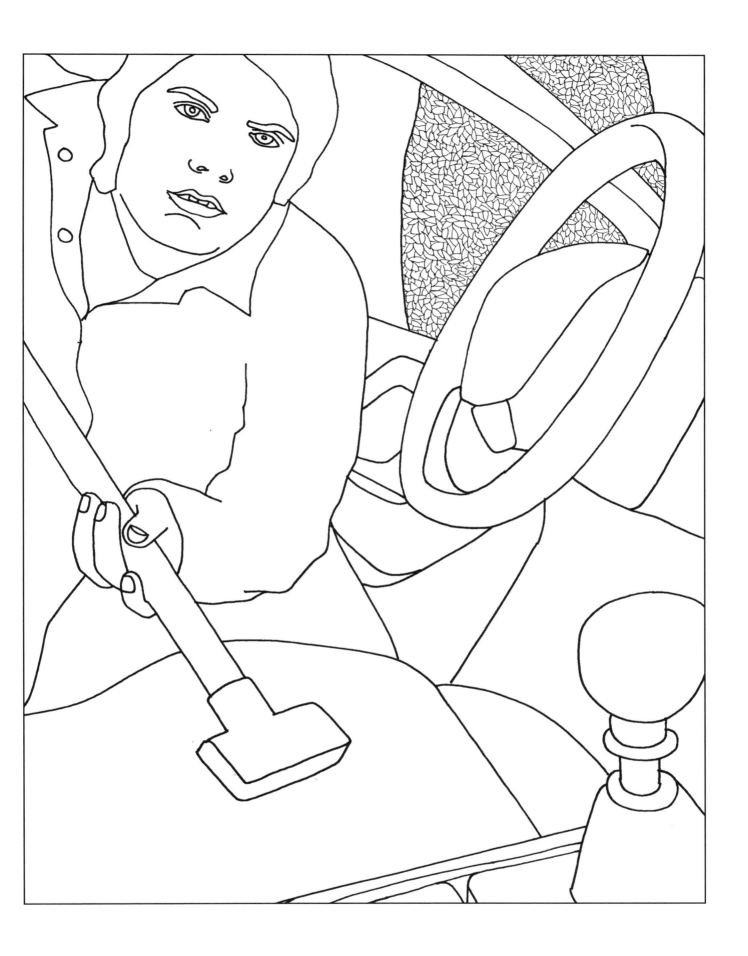

**During the week I eat a lot of dry roast peanuts.
At weekends I vacuum the nut dust from the seats.**

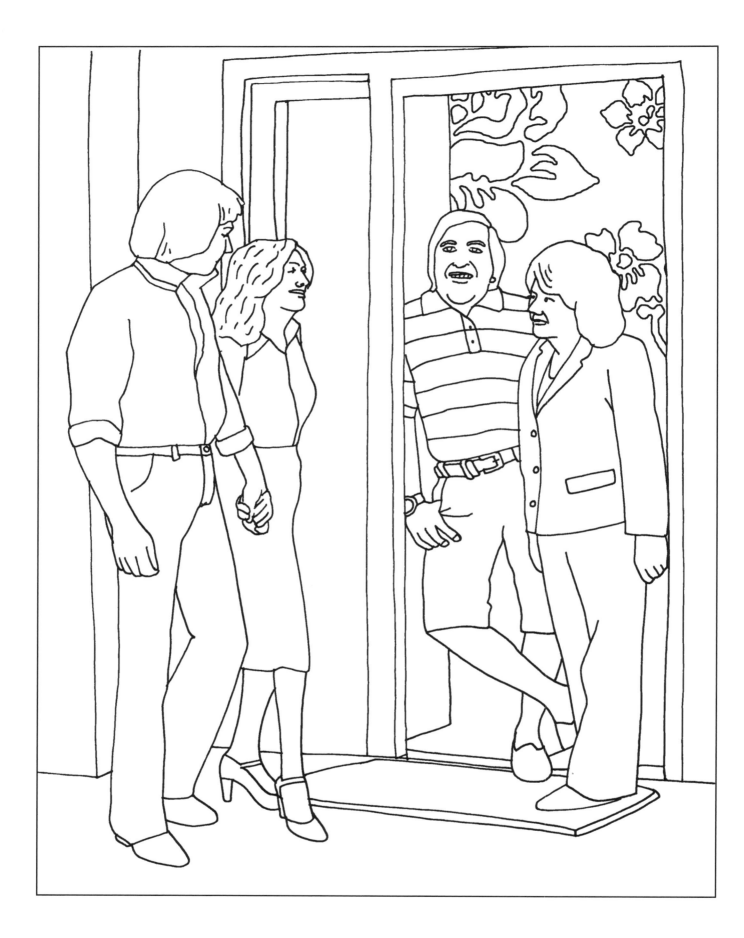

'Hi, we're from next door? We're having
a bit of a party tonight.'
'Okay, great, what time do you want us there?'

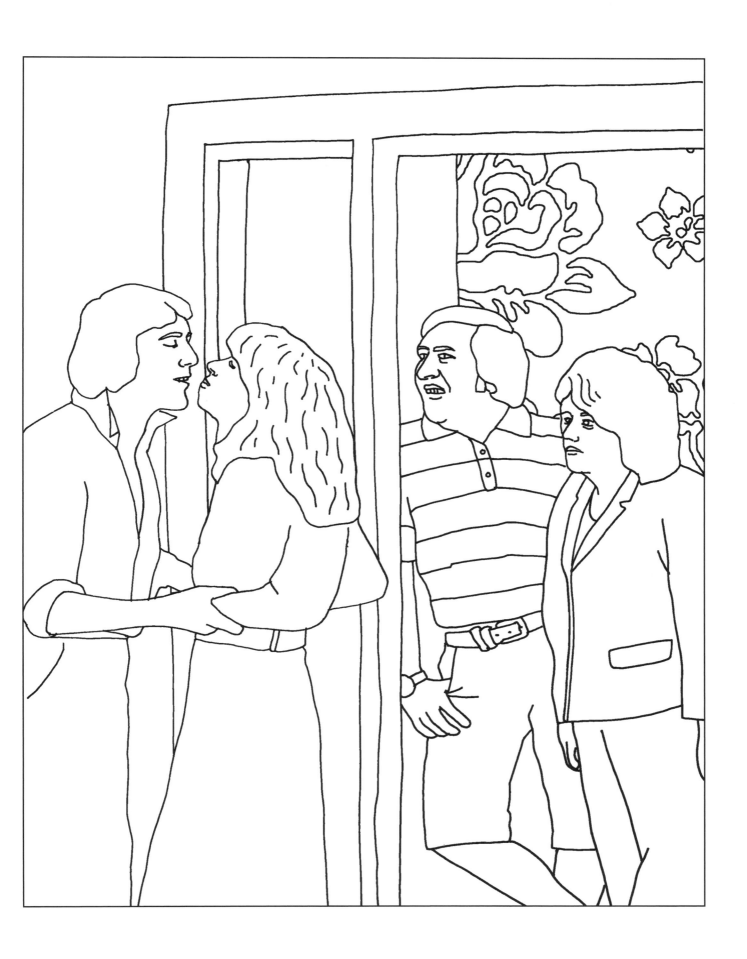

'You're not invited, just thought we better let you know
as there's going to be quite a bit of fucking noise.'

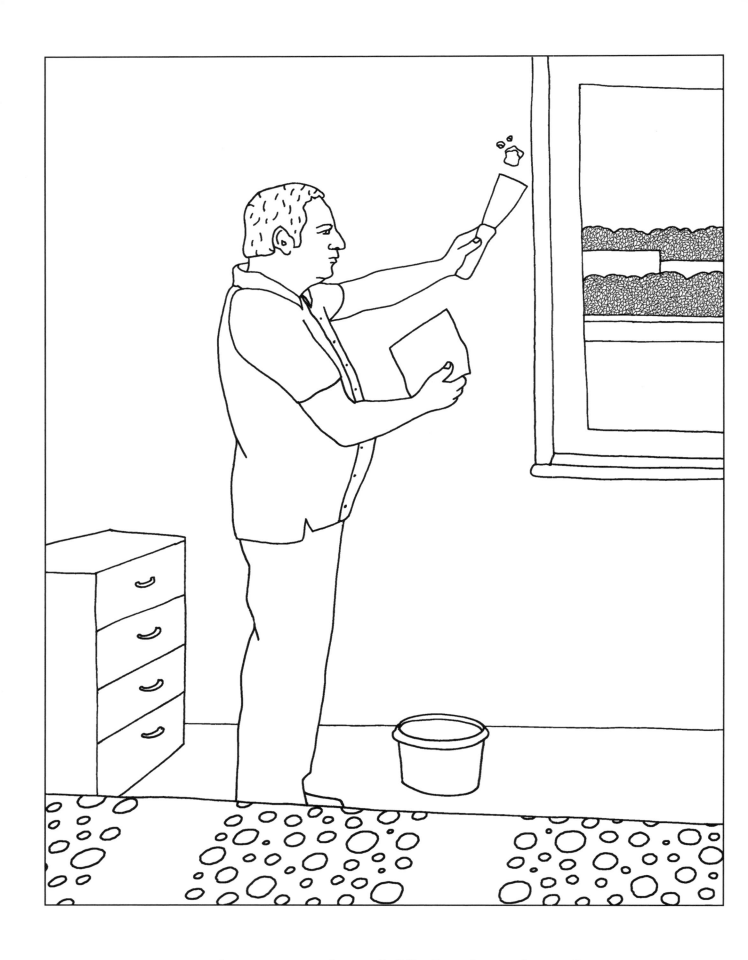

**Before I sand and fill this bit of wall
I might just eat a chocolate biscuit.**

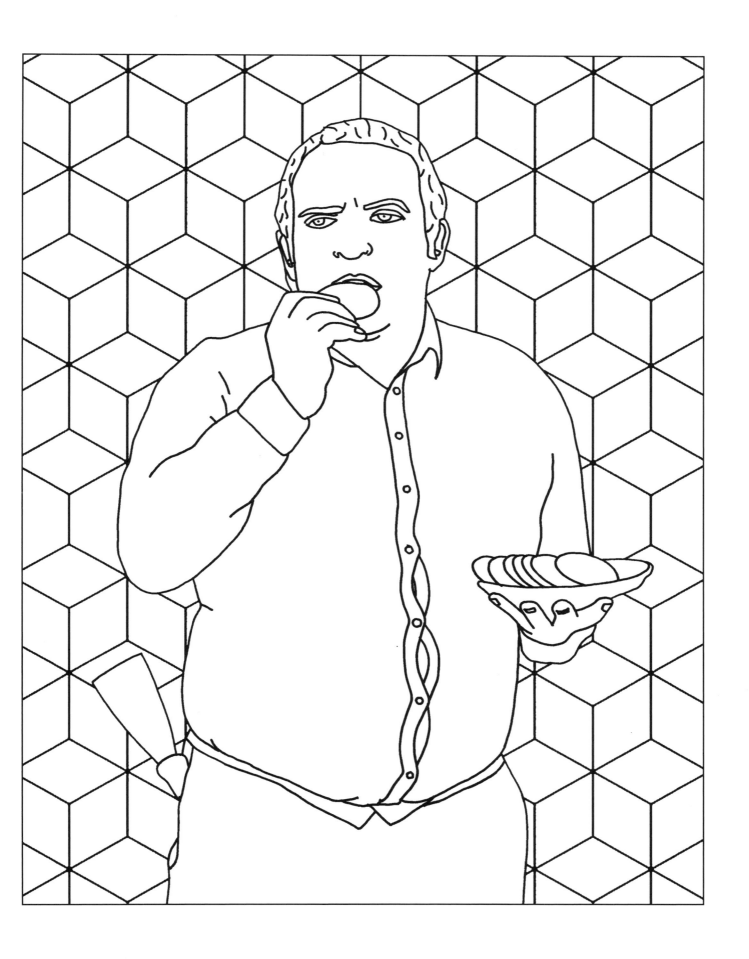

Fuck it, I can do that DIY stuff tomorrow.

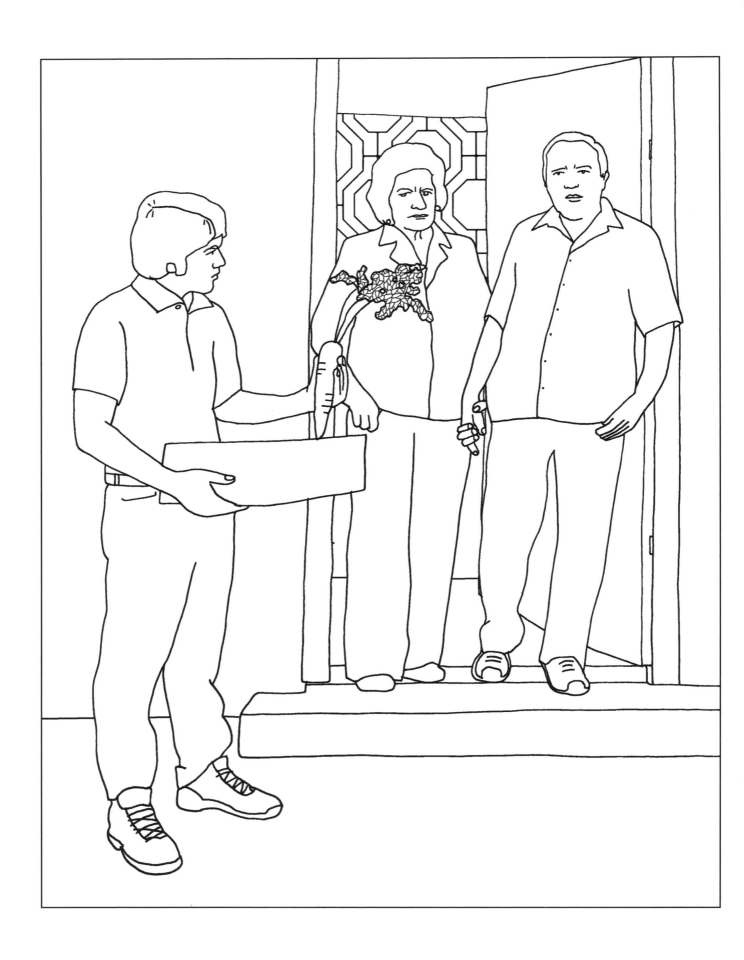

'Can I interest you in a weekly organic veg box? If you sign up now you're entitled to this incentivisational carrot.'

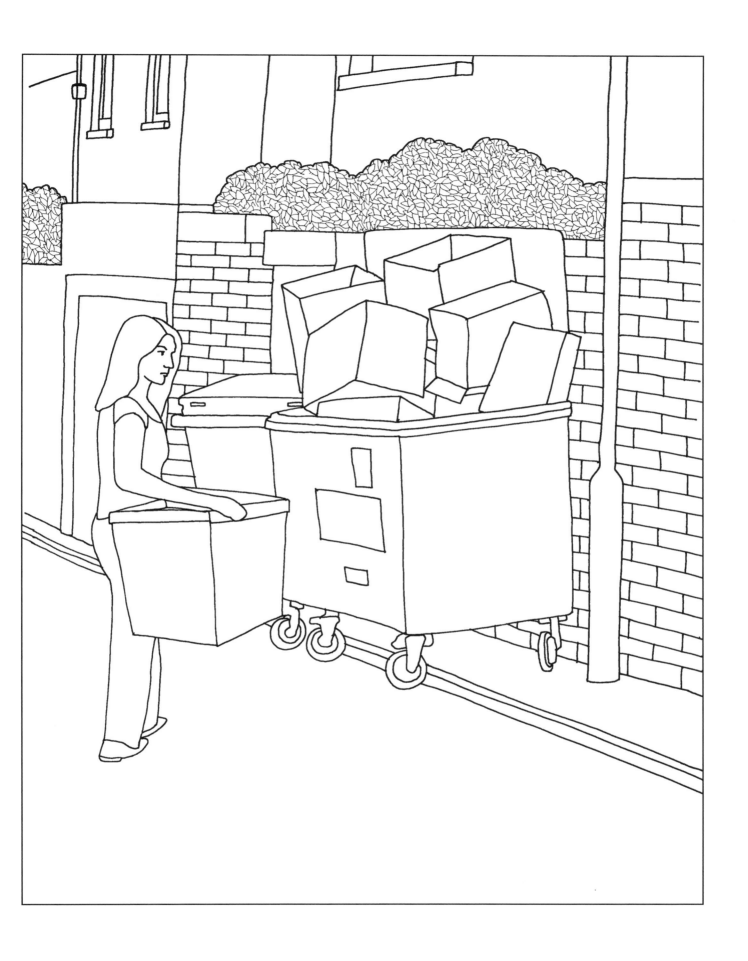

Some cunt's put a load of unfolded cardboard in the recycling.

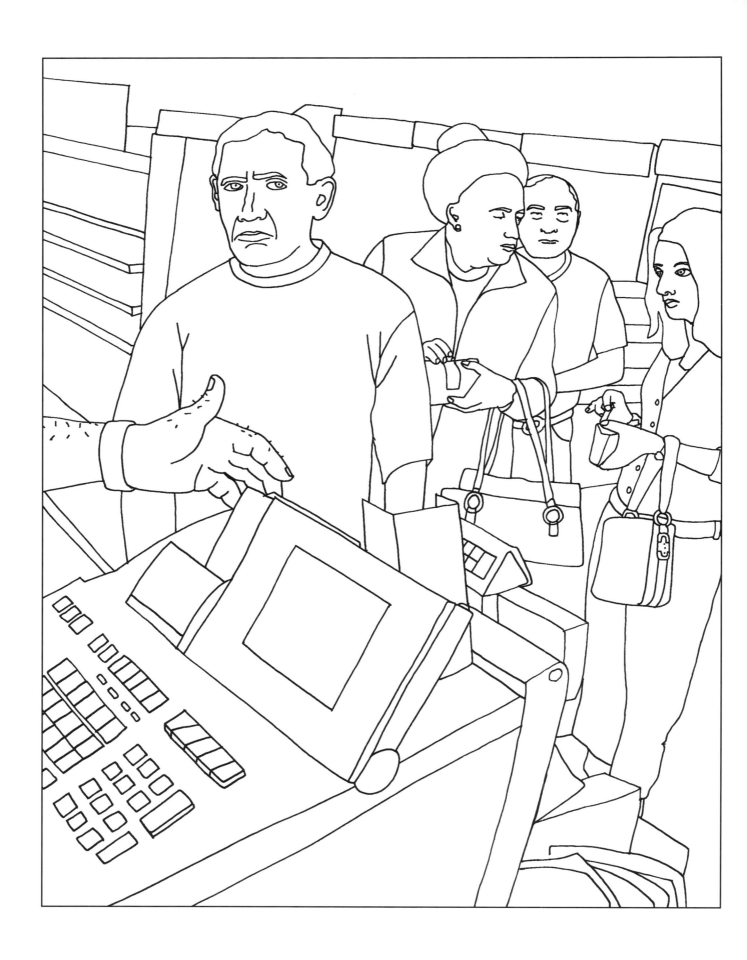

**I fancy getting a lottery ticket. My lucky numbers
are the combined death dates of my last two pets.**

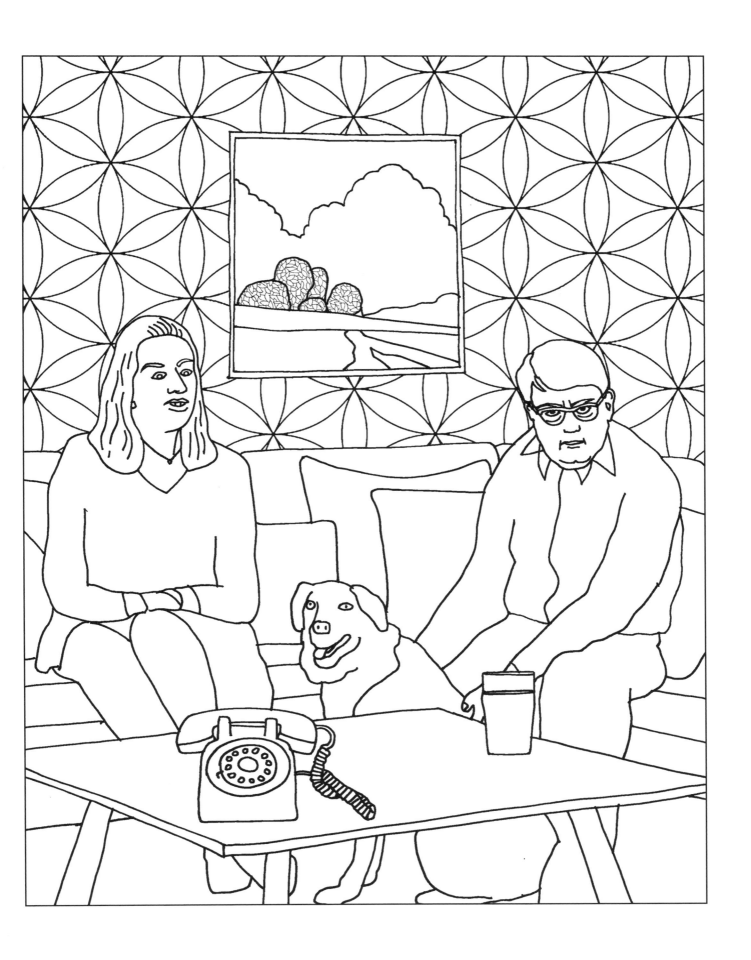

One of our parents is trying to call us on the landline.

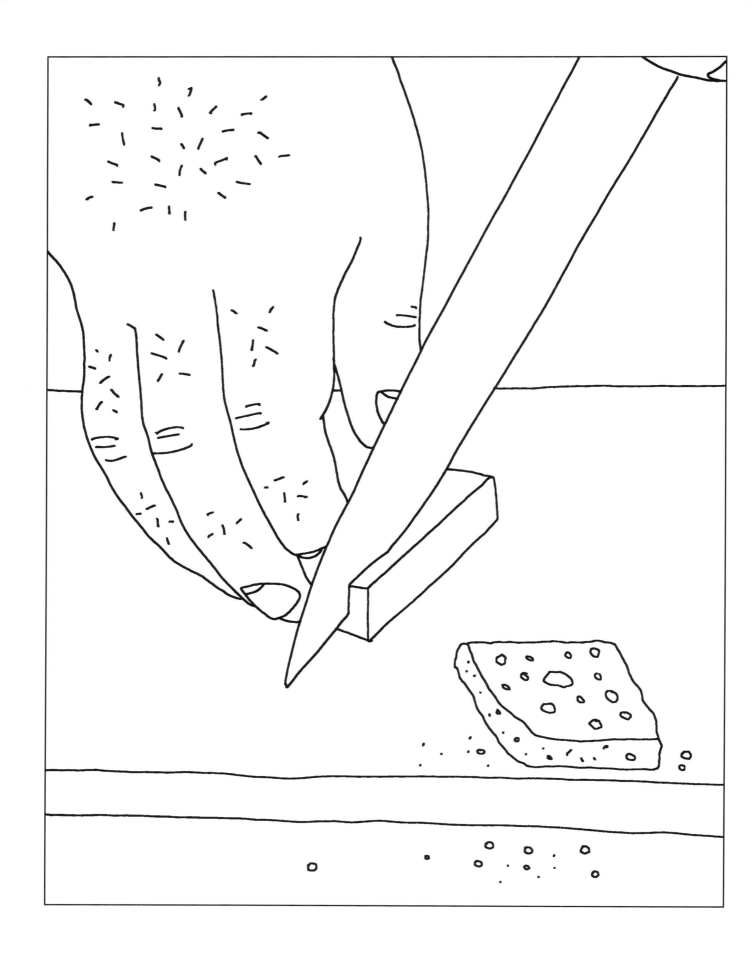

Mid-afternoon I make a micro snack with one slither of cheese and a quarter slice of bread.

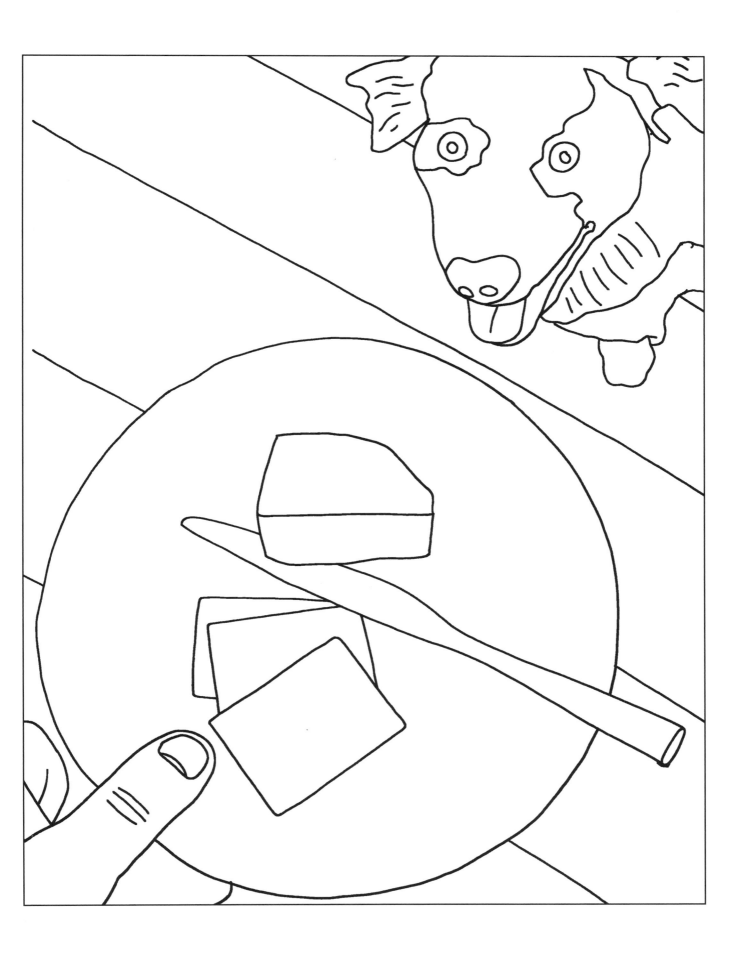

**The opening of the fridge door alerts
the dog to the presence of cheese.**

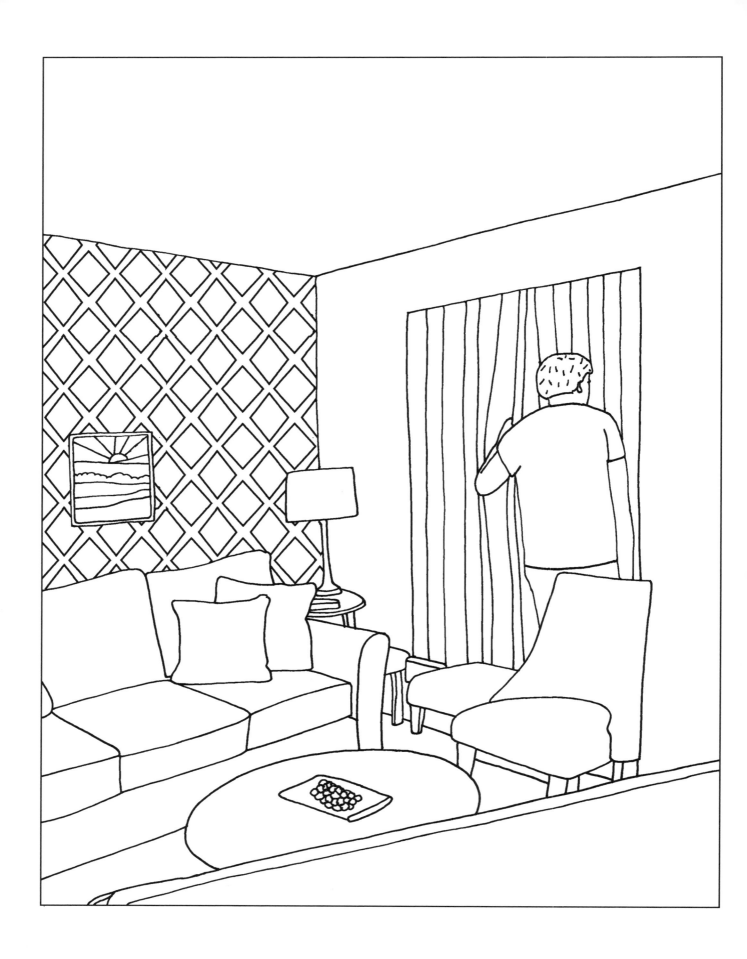

Just settling down for a three-hour block of Come Dine With Me when some arsehole starts banging on the door.

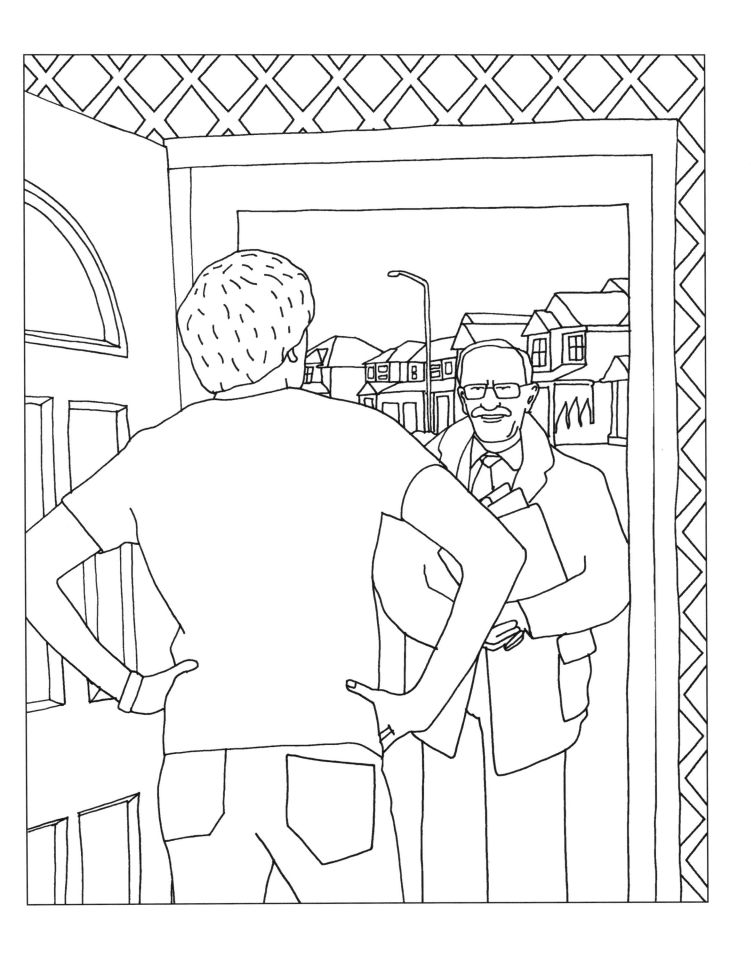

'Can I interest you in signing a petition to stop a new traffic scheme which will allow people to park near the shops?'

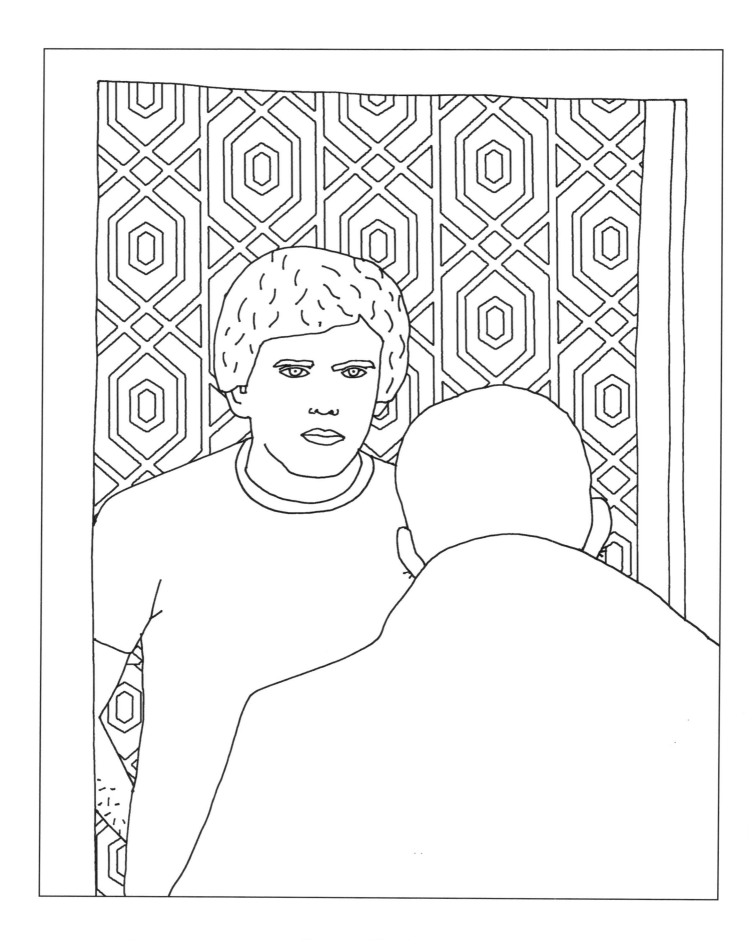

'Sorry, I'm actually really busy at the moment.'
'Shall I pop back?'
'No, don't bother, I like parking near shops.'

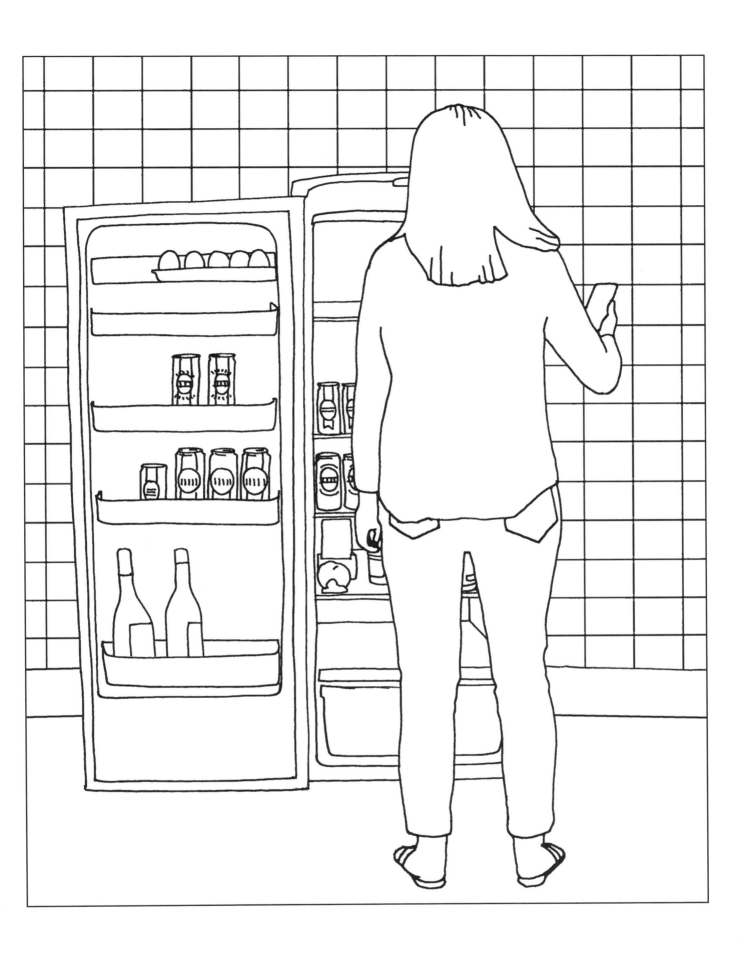

It is still slightly too early for a drink.

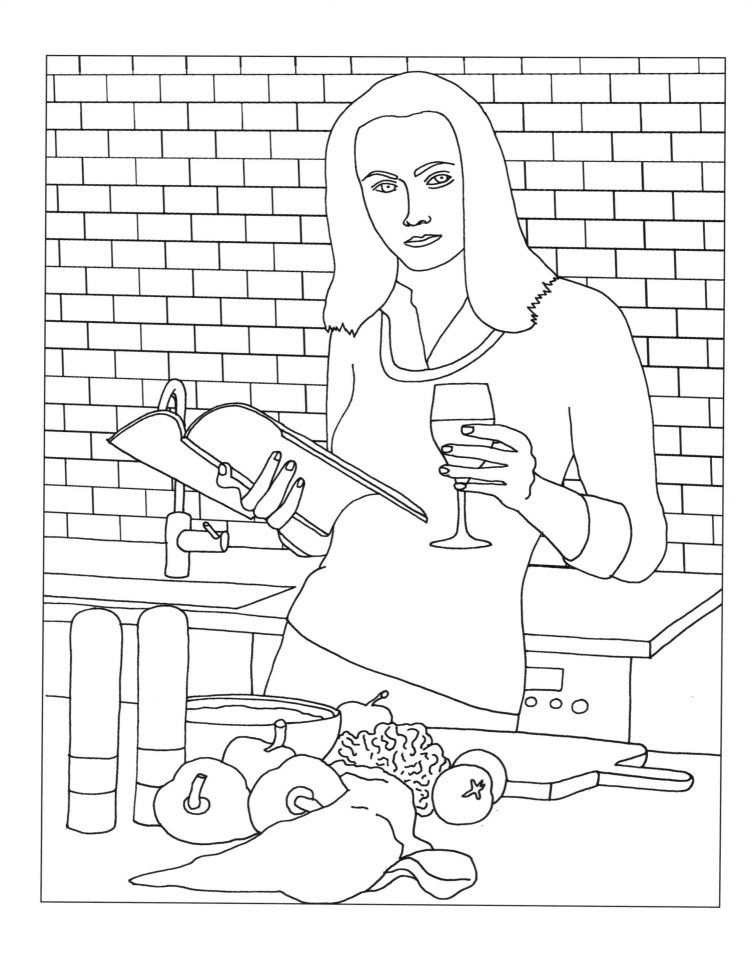

**I was going to make the casserole recipe
in this weekend supplement magazine,**

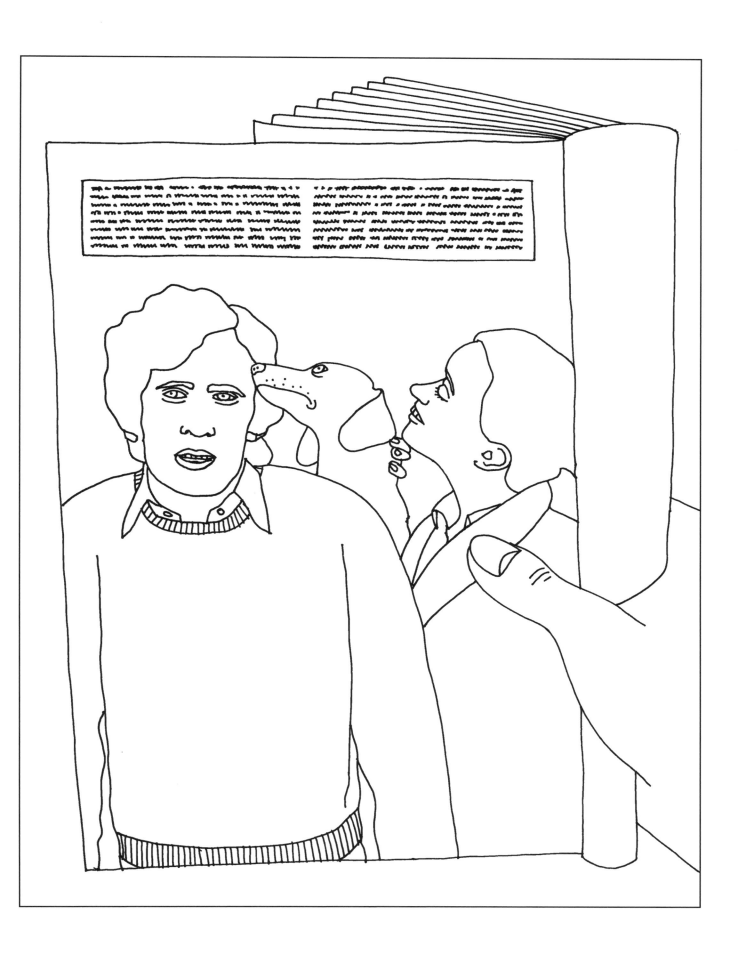

but the article next to it about dogs that can
smell human brain tumours has put me right off it.

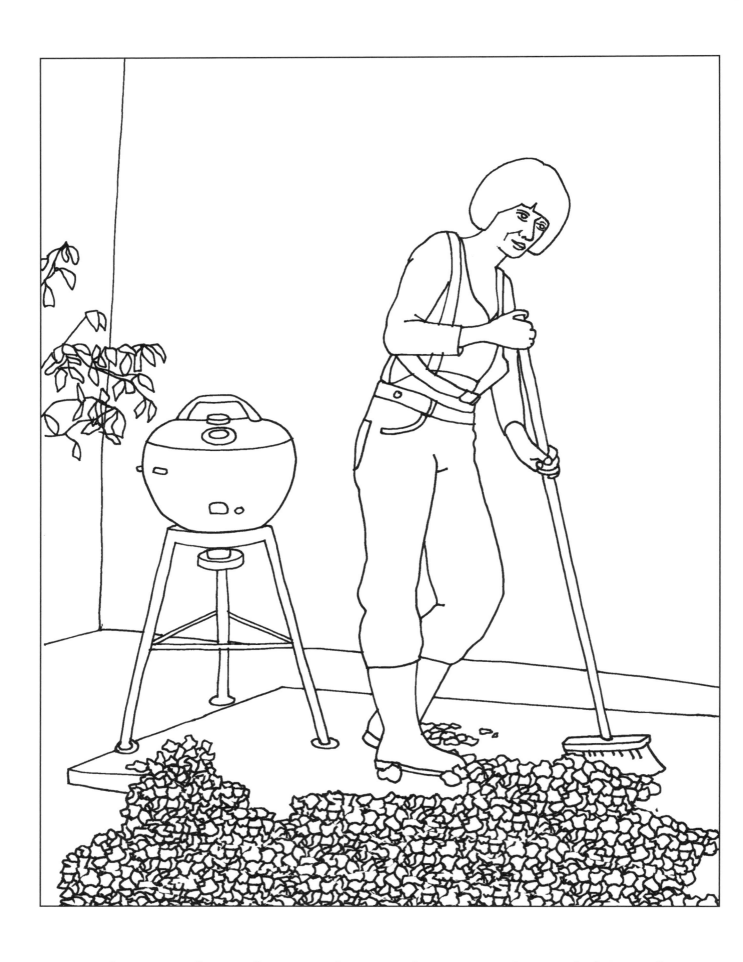

Time to clear the garden and scrape the soft bits of congealed fat off the barbecue with a teaspoon.

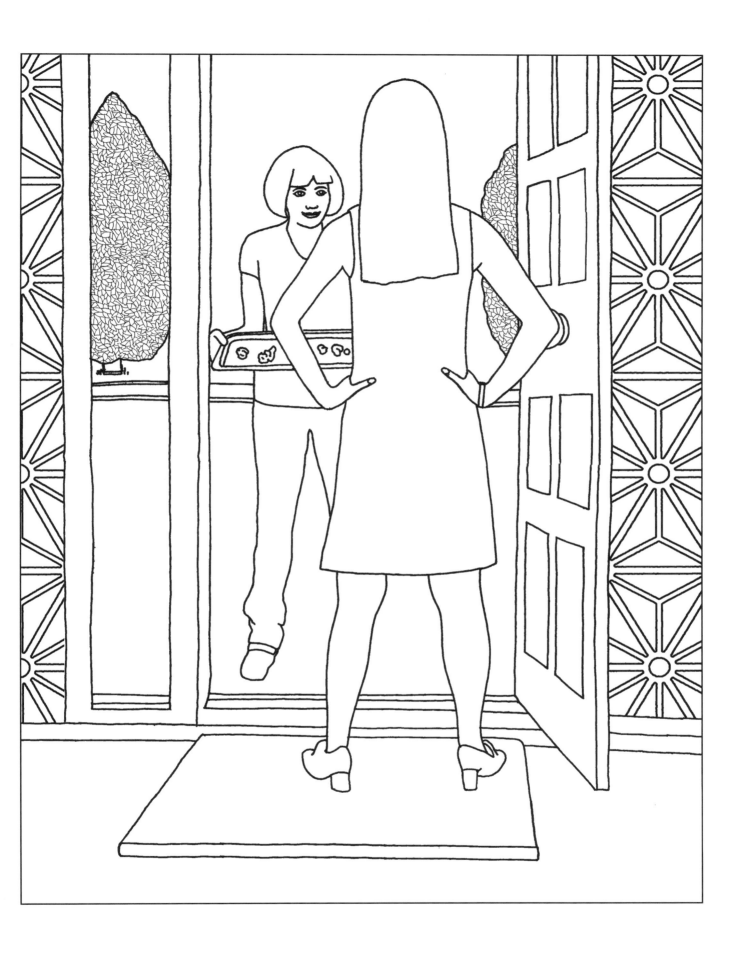

Hello, I'm returning some of your cat shit from our garden.

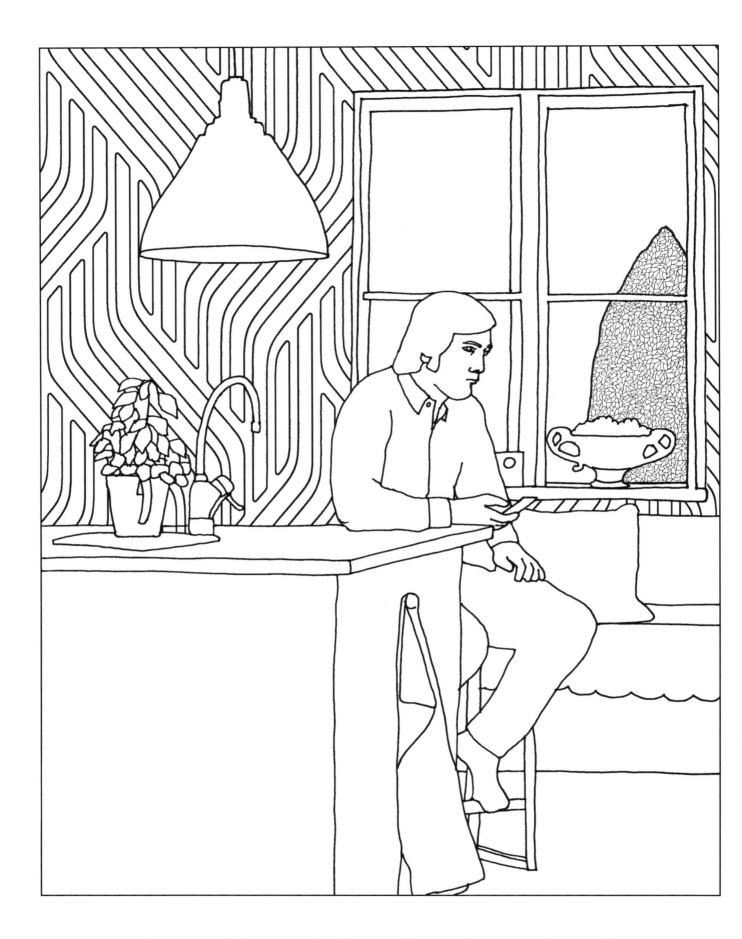

I am a bit worried we don't have a broad
enough selection of drugs for our dinner party,
better give my local drug dealer a call.

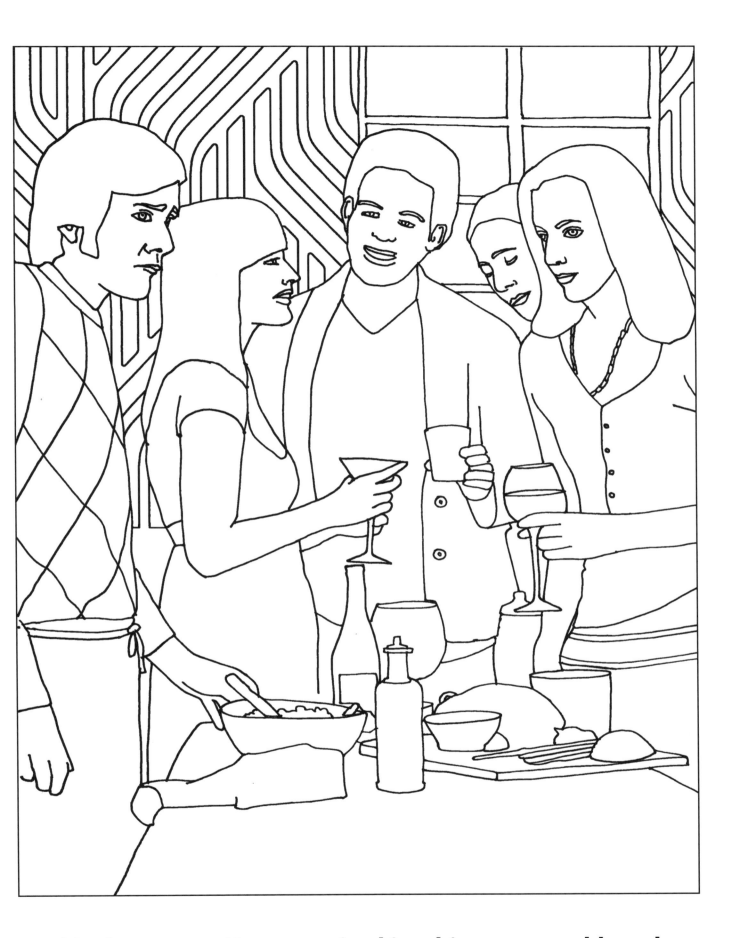

This drug party I've organised is a big success, although I'm worried a couple of people might have shit themselves. I'll just put the extractor fan on for a bit.

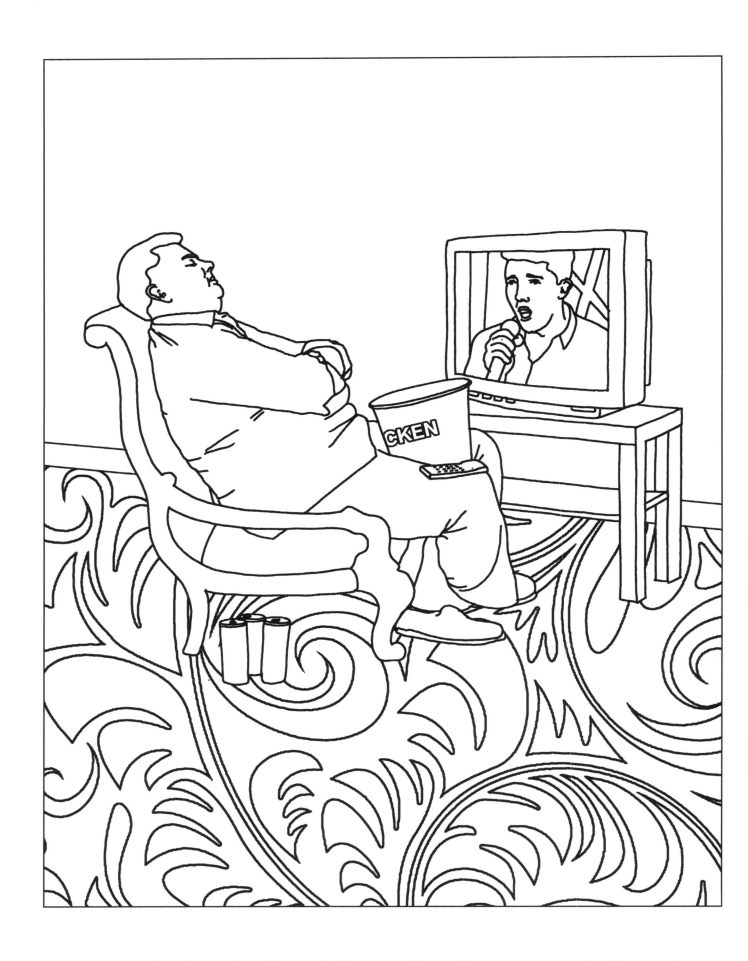

I get a chicken bucket delivered early evening before the main artery delivery routes get furred up with mopeds.

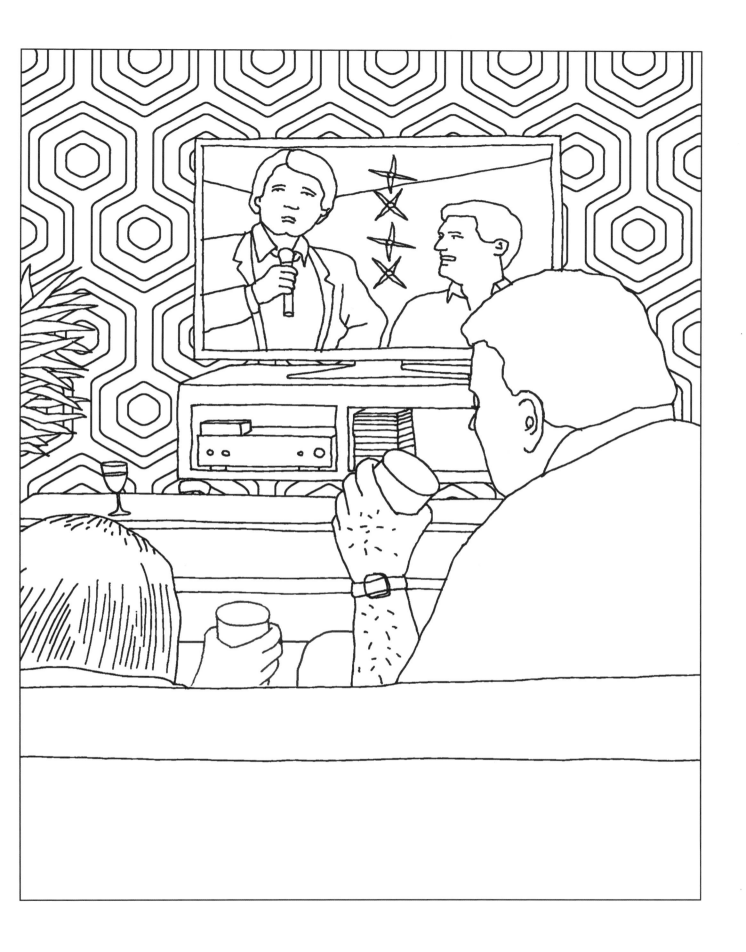

**I see Top of the Pops 1982 is on again, obviously
these two DJ's have full nonce clearance.**

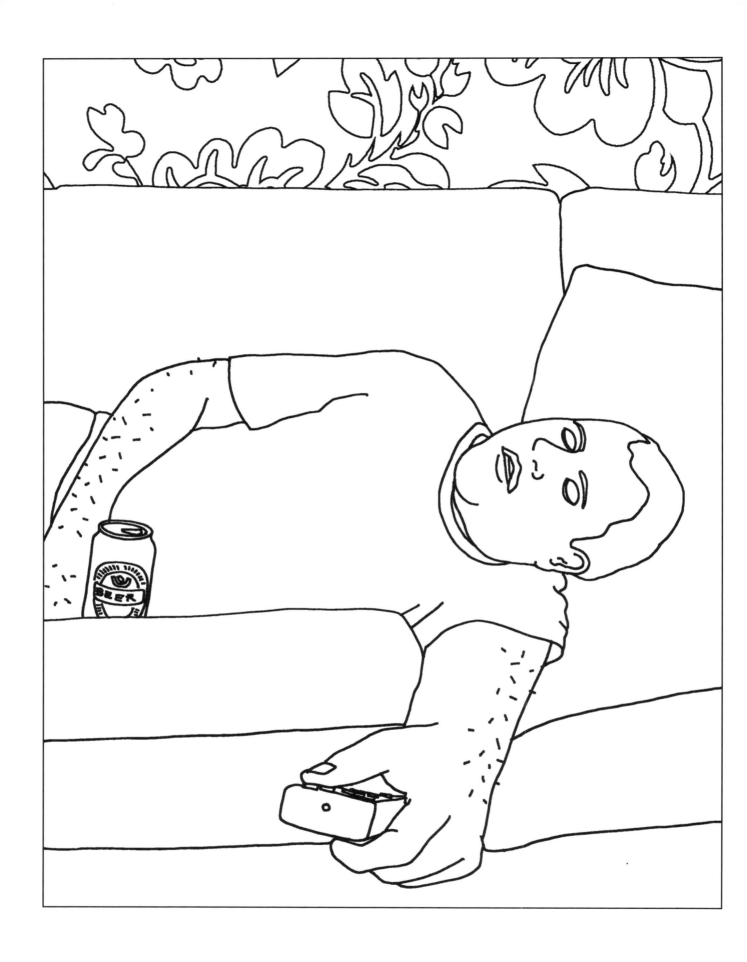

I wake up in front of the TV. Super Casino is on.
I haven't pissed myself. Looking forward to Sunday.

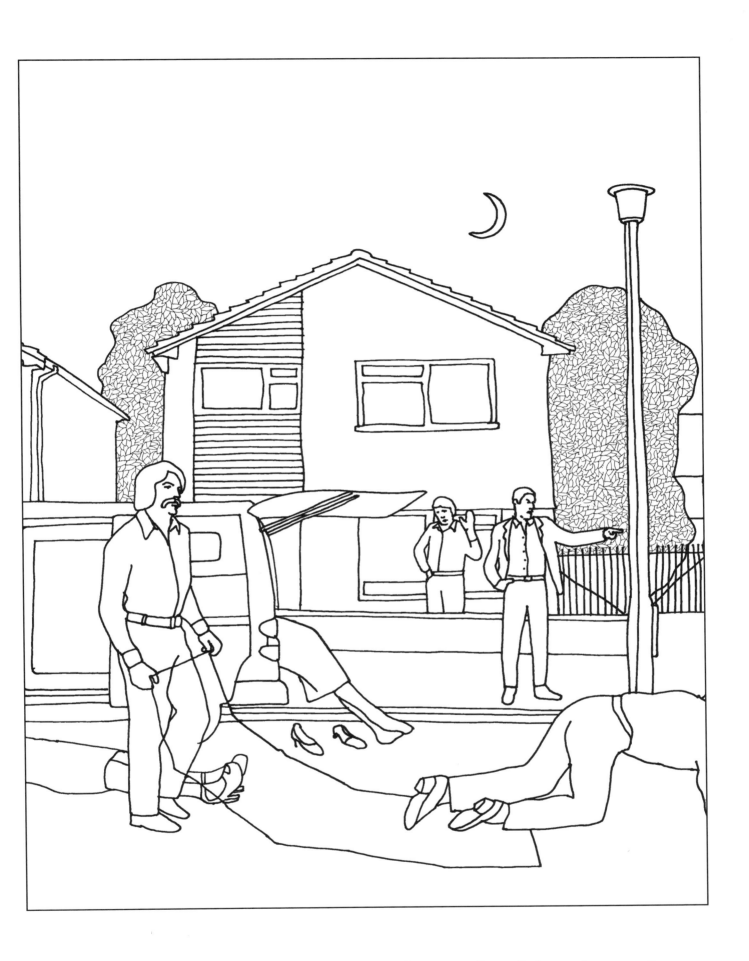

The party's over and the taxi is here. The driver is getting out some plastic sheeting for our guests' journey home.

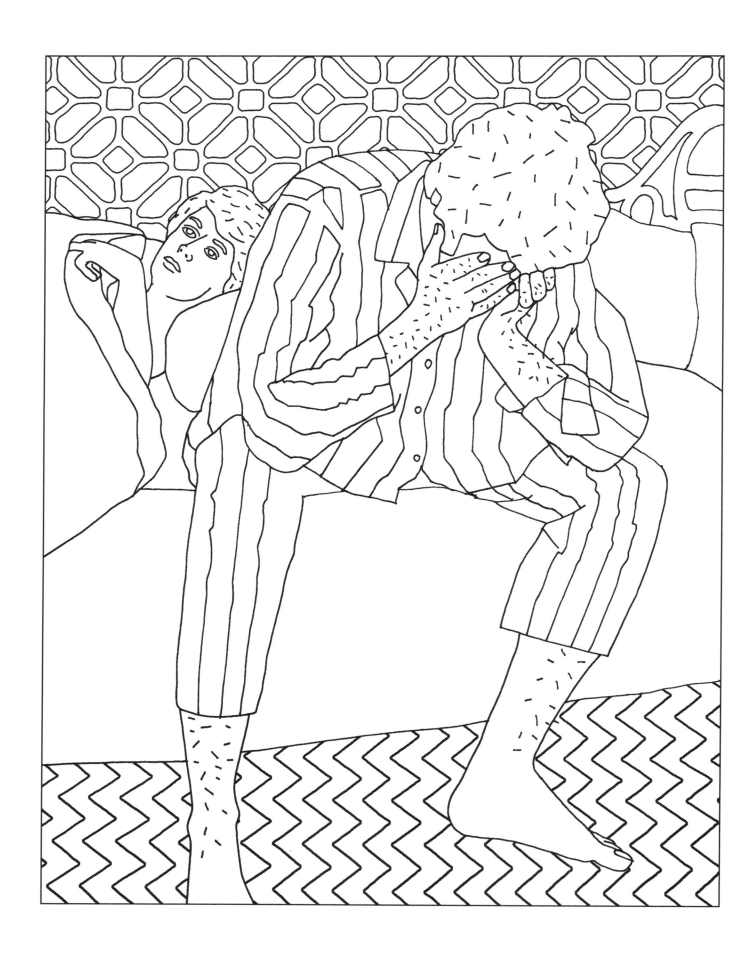

Early Sunday morning. Some fucker is revving a motorbike.

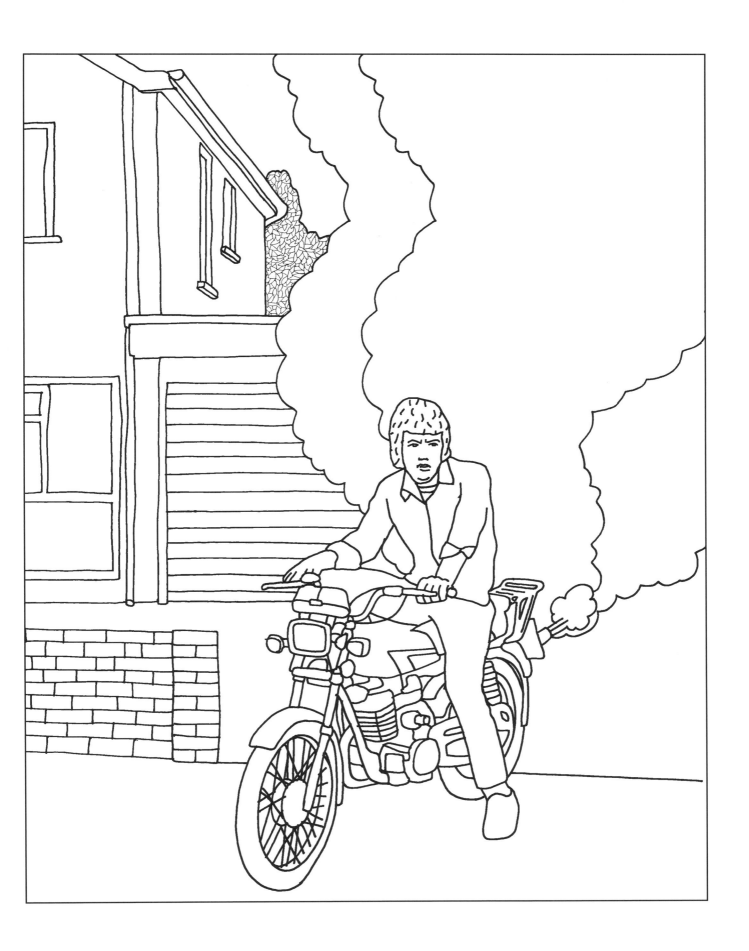

I like to get up early and test the noise level on my motorbike when it's fully revved up. A full test takes about an hour.

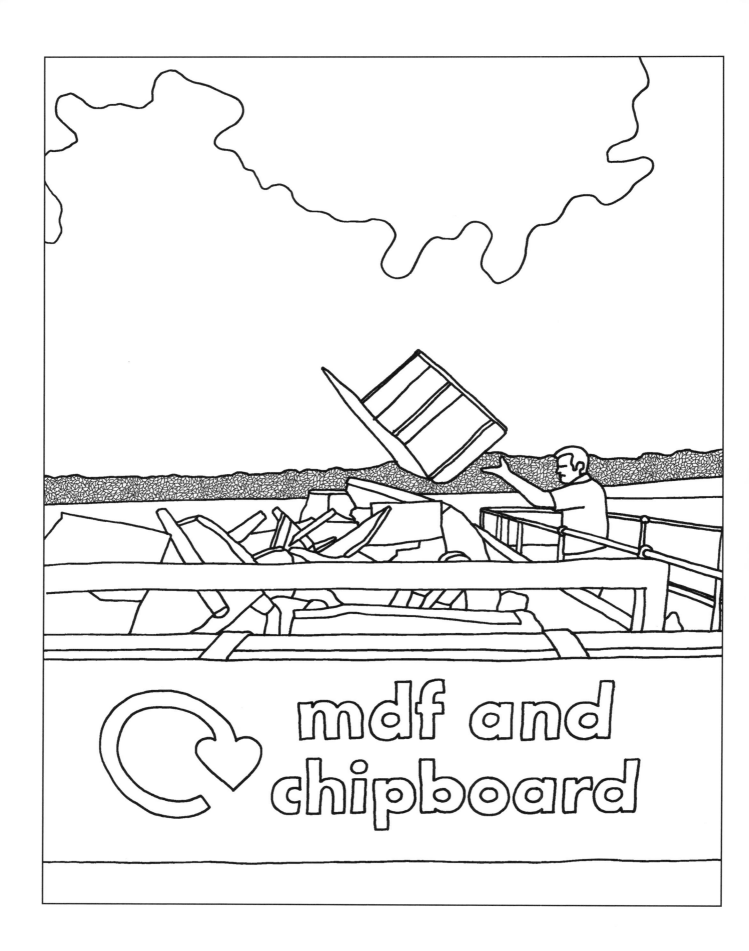

I'm up the dump as soon as it opens. I like the noise my furniture makes when I throw it in the skip.

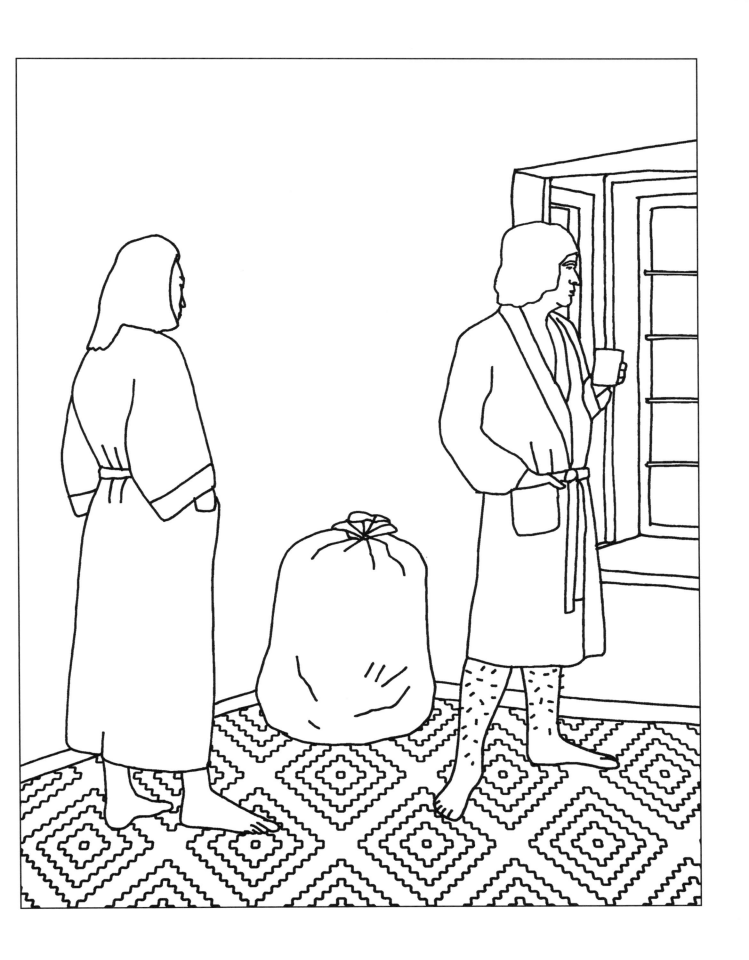

**One day he will take that bin liner full
of clothes to the charity shop.**

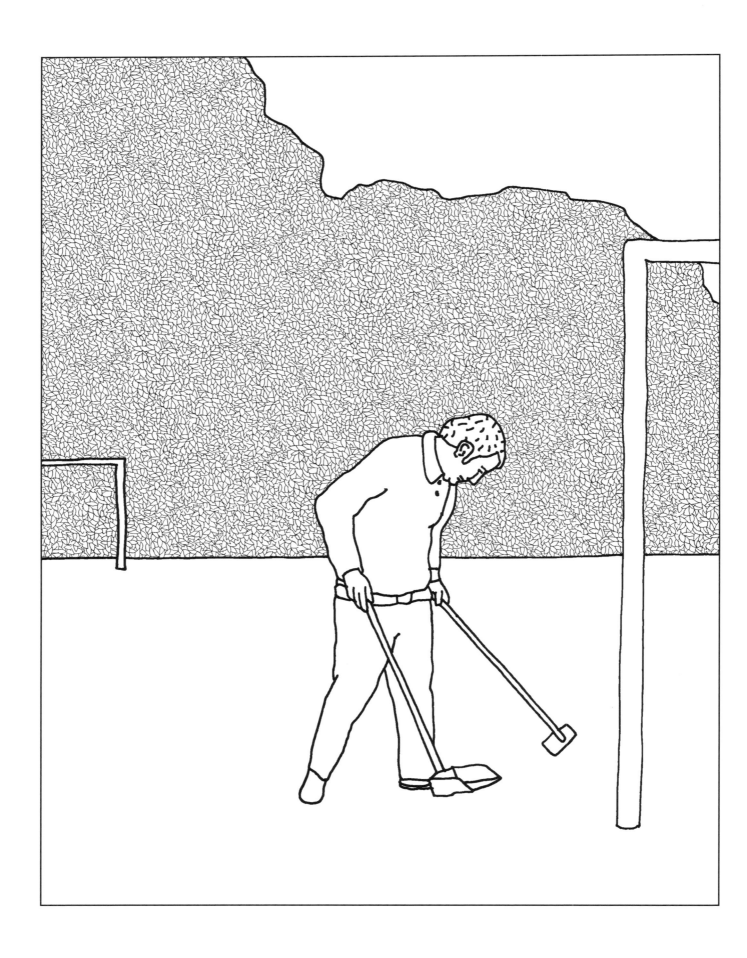

Big match for the kids' football league this Sunday.
It's my turn to check the pitch for dog shit before they start.

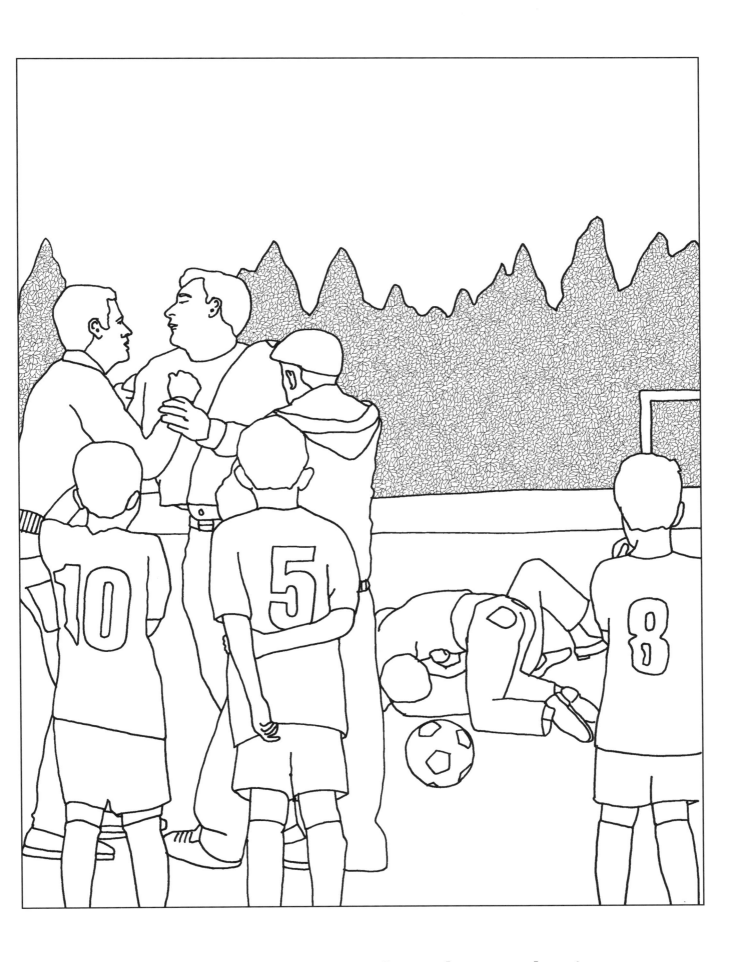

**Some of the parents and coaches are having
a disagreement over second half substitutions.**

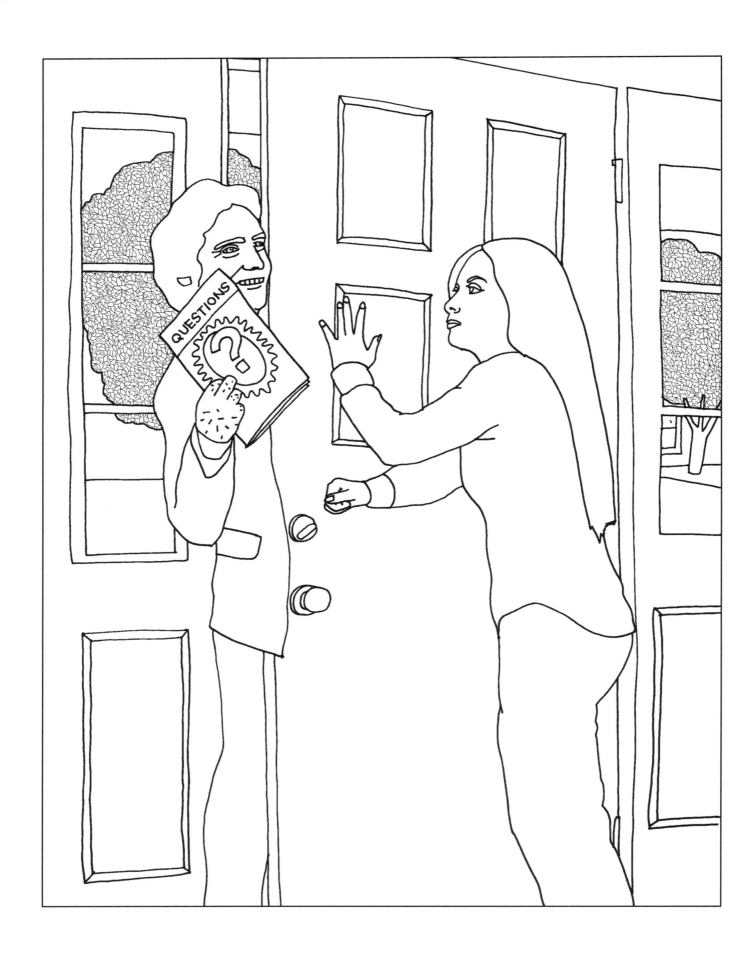

There's a bloke at the door asking me if I've got any questions about why the world is getting worse.

**That's a big question, I'll have a think about it after
we get back from the outdoor sex club.**

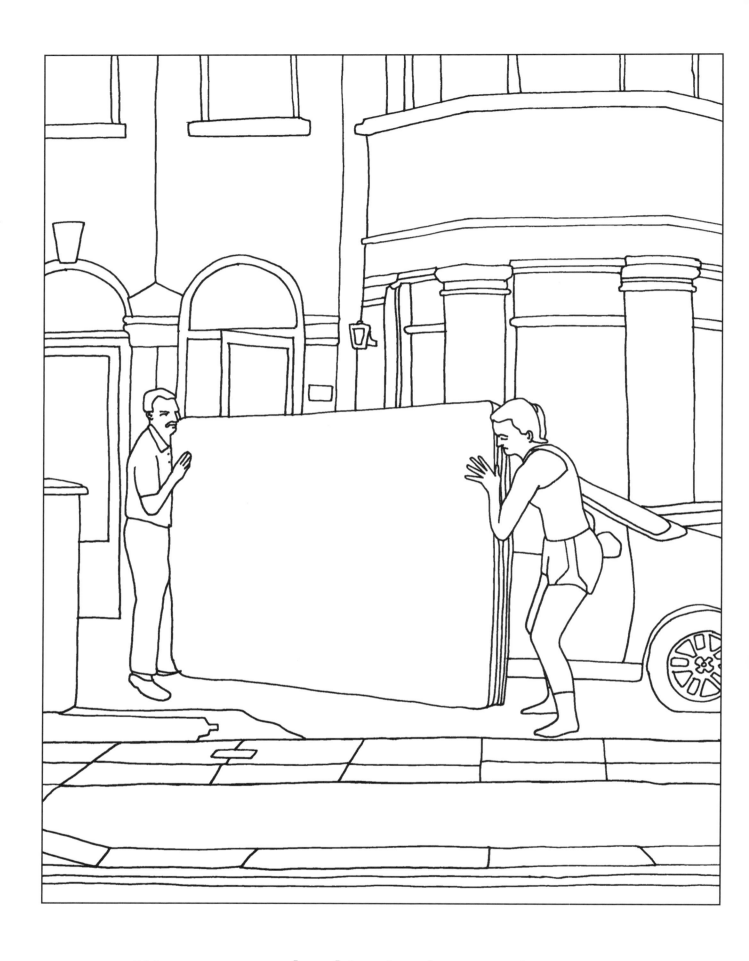

We want to take this piss-damaged mattress up the tip, but it's too big to get in our car.

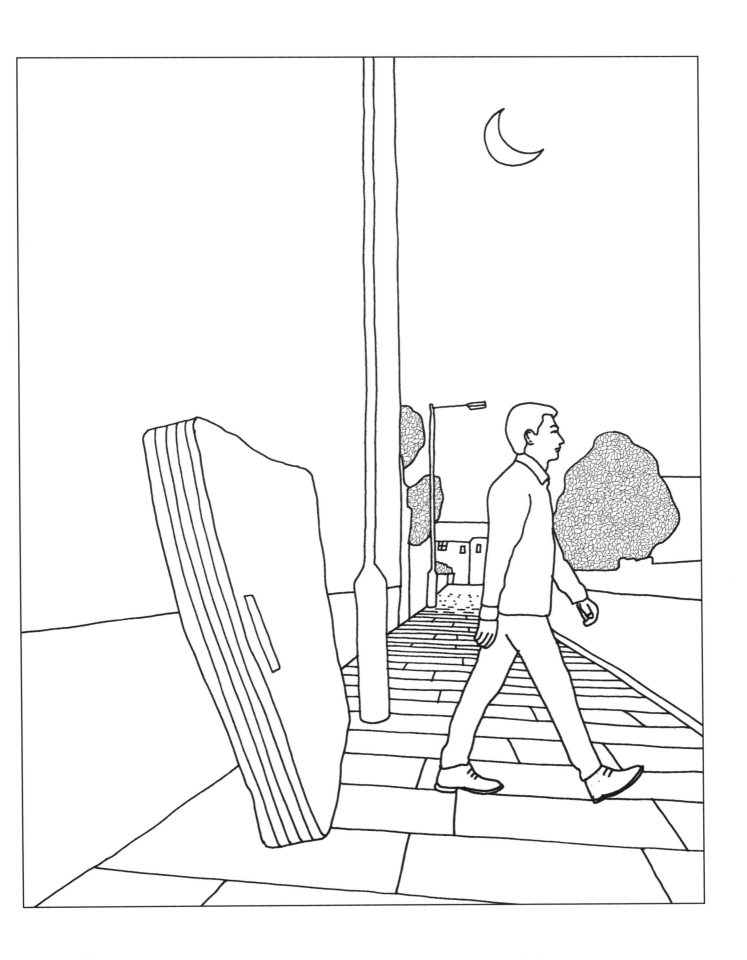

I'll probably wait until it's dark and leave
it against a wall down the road.

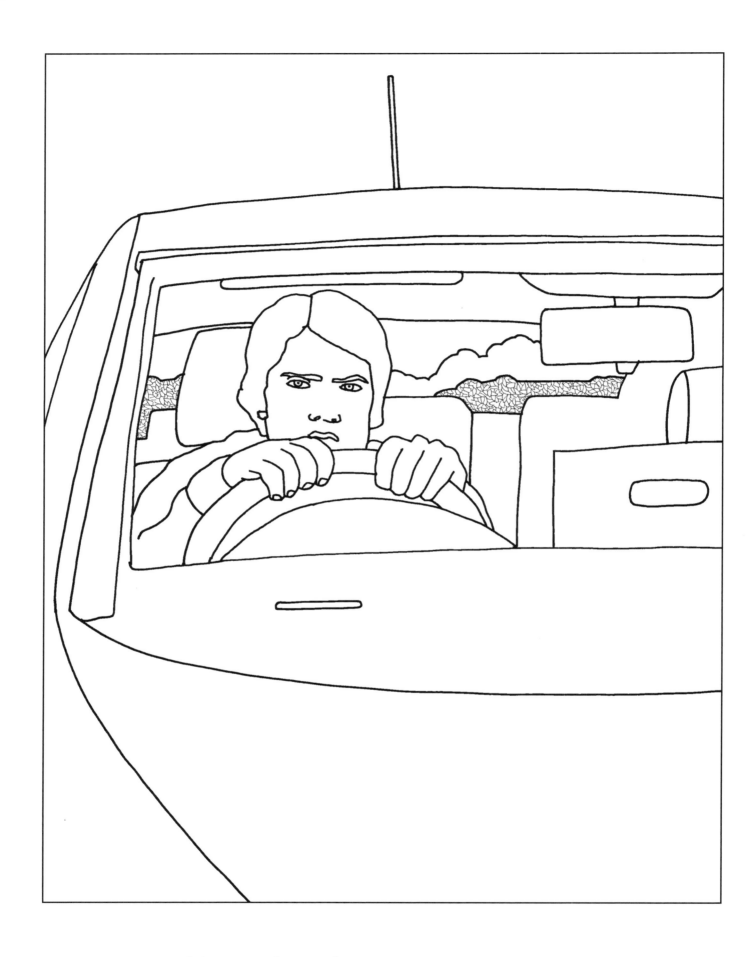

**This Sunday afternoon I am spending
two hours stuck in traffic.**

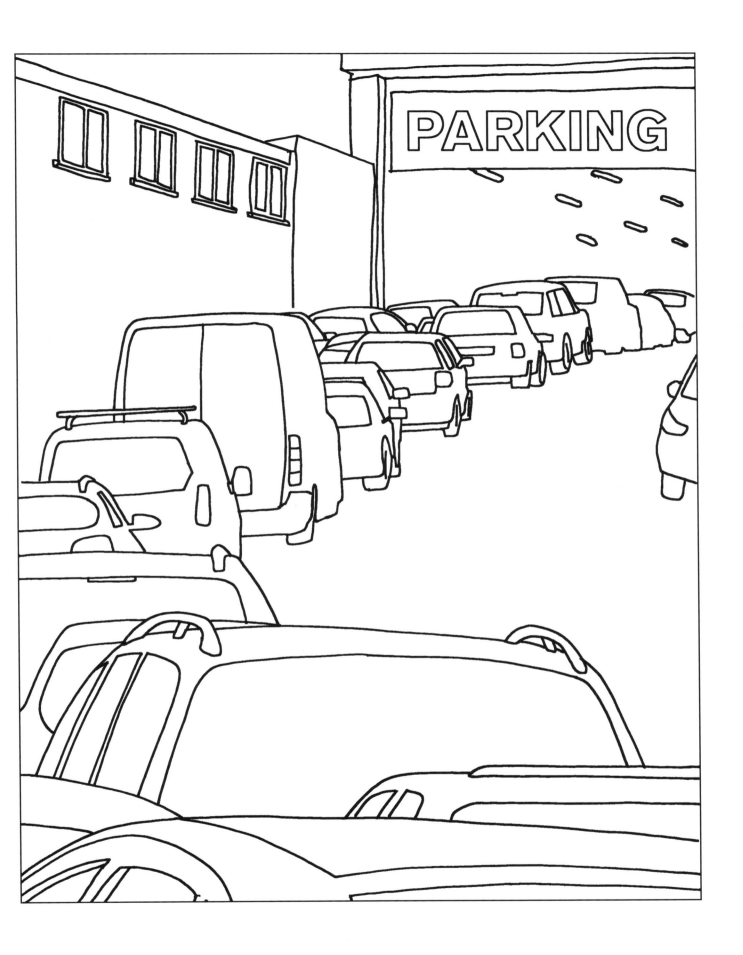

I'm taking back a pair of work trousers that have given me a rash due to the synthetic material rubbing on my leg.

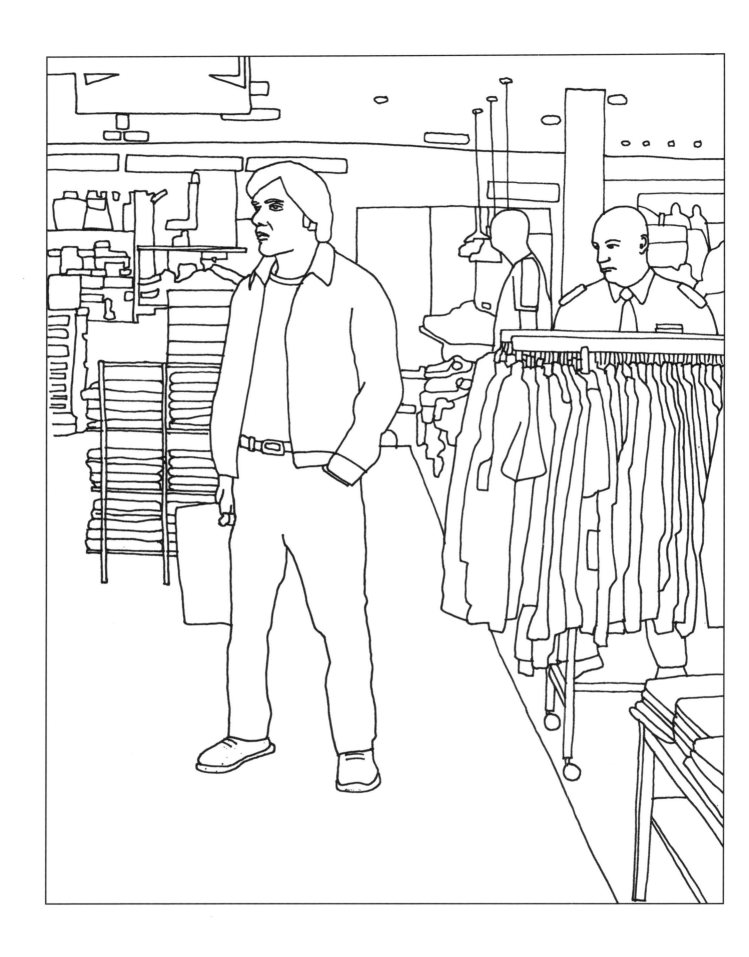

**I'm in the shops. Might buy some socks but I'm put off by
a security man who is pretending not to be following me.**

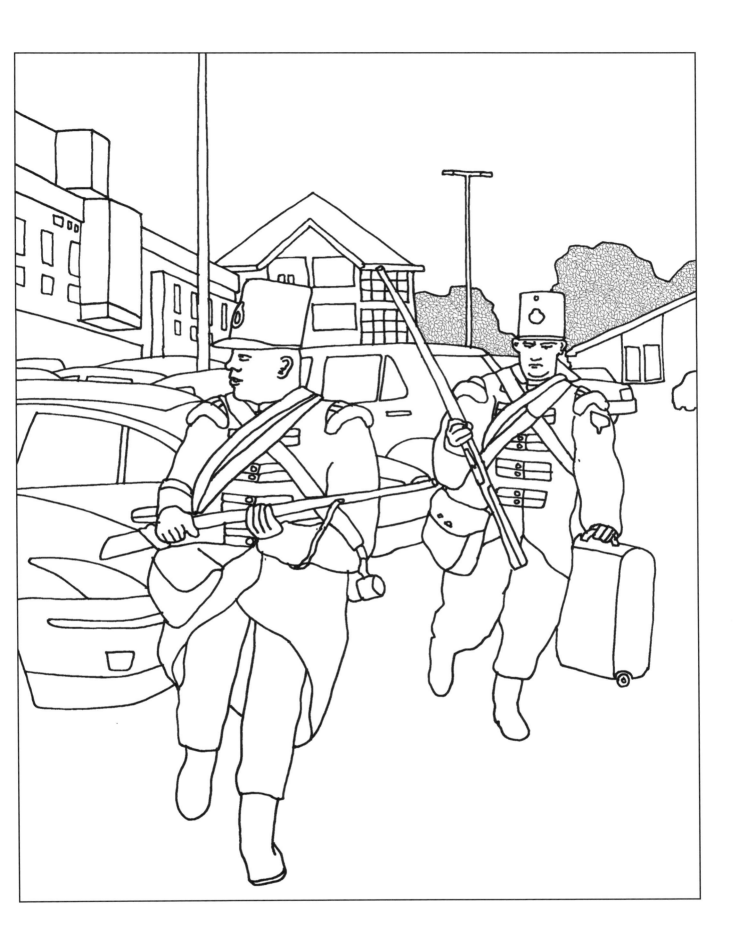

**Due to congestion on the dual carriageway we are
late for our battle re-enactment weekend.**

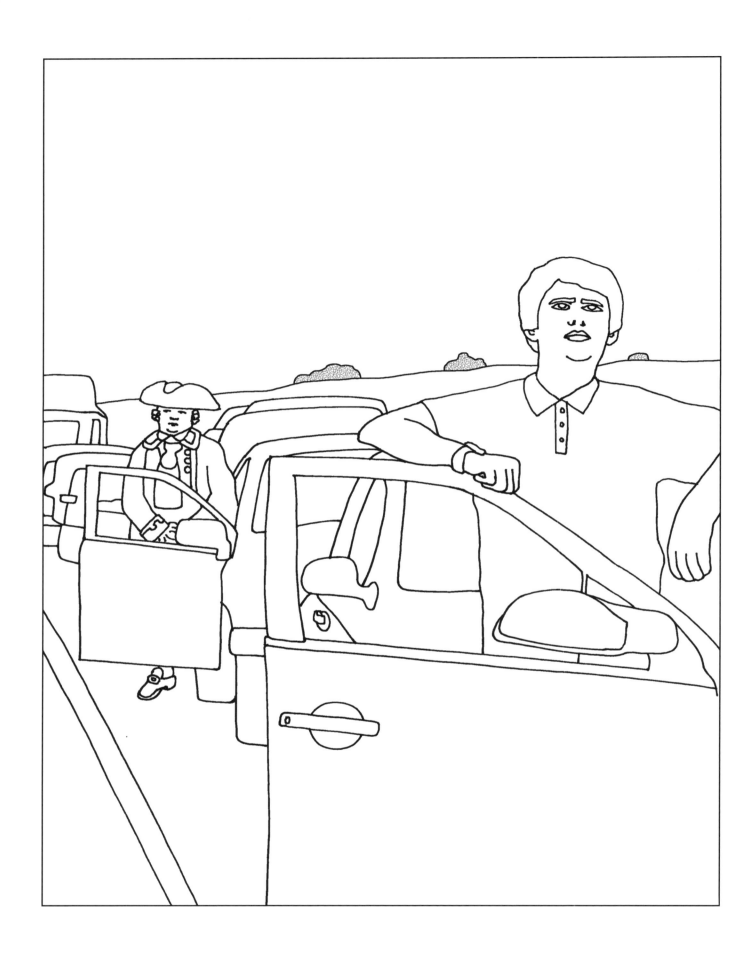

There is a battle re-enactment in the field next to the car boot sale. Traffic is much heavier than usual.

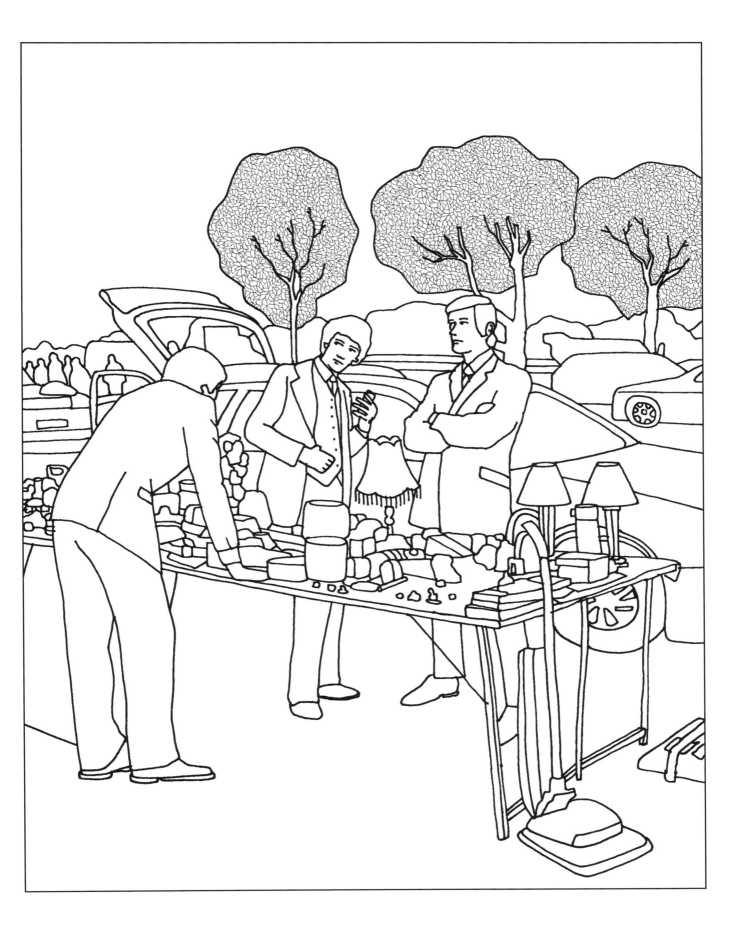

I can't believe this pair of cunts have rejected
my offer of eighty-three pence for the small trinket
next to the broken Star Wars toy.

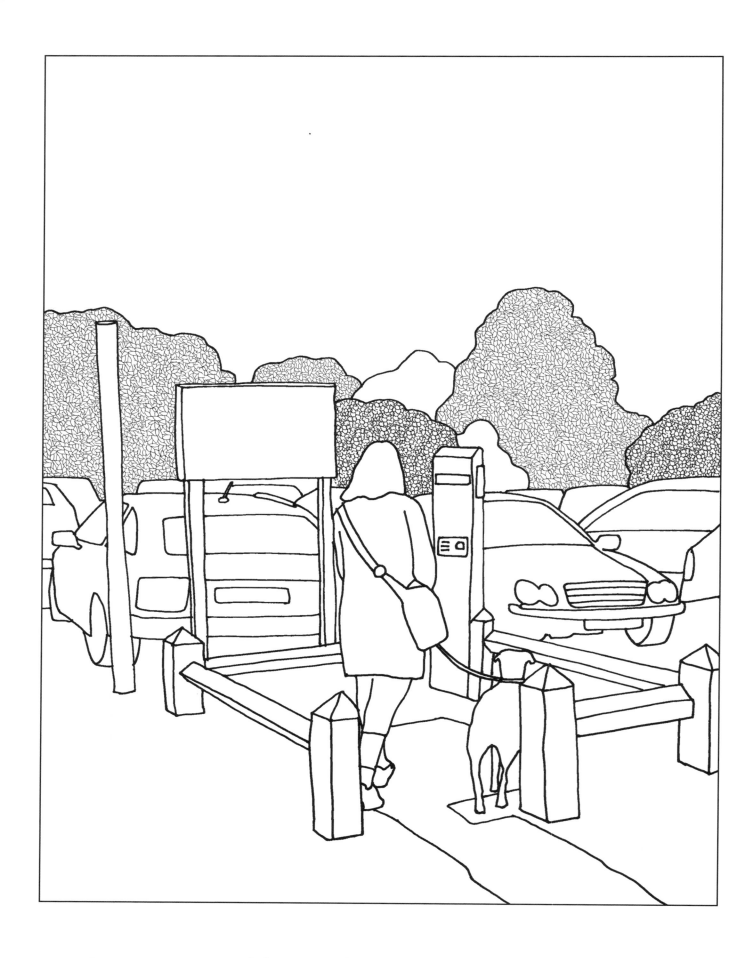

**It costs two quid to park your car in the countryside.
For local outdoor sex clubs, it's free after 8pm.**

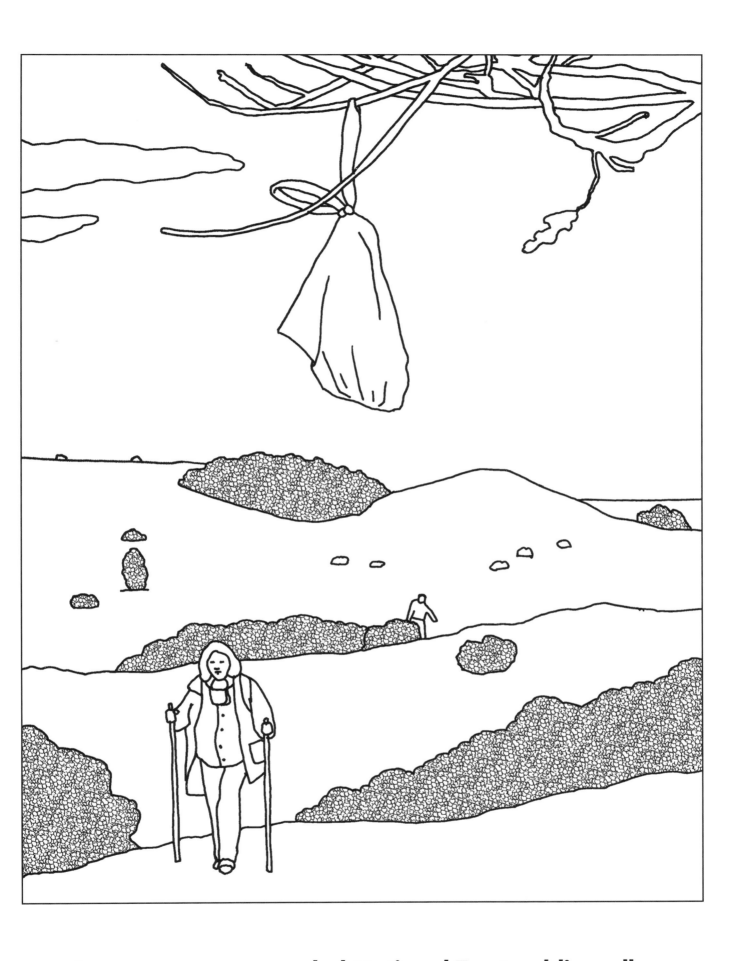

**I am on a recommended National Trust public walk.
I see someone has hung a bag of dog shit from a tree.**

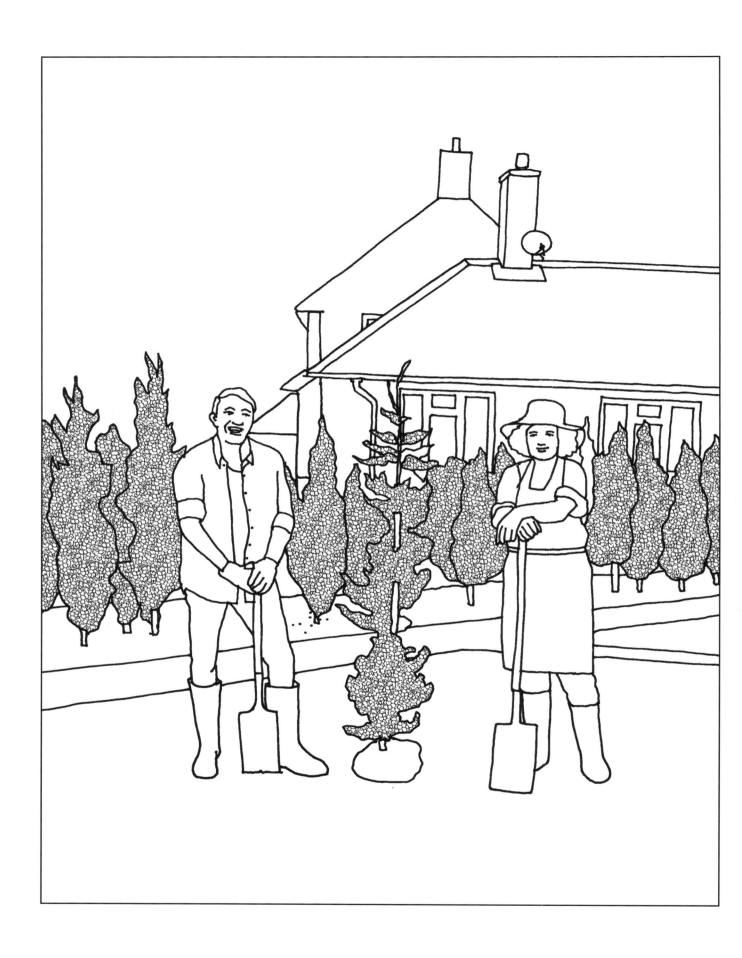

As part of a dispute with our neighbour we are planting some fast-growing trees to block out the sunlight from his garden.

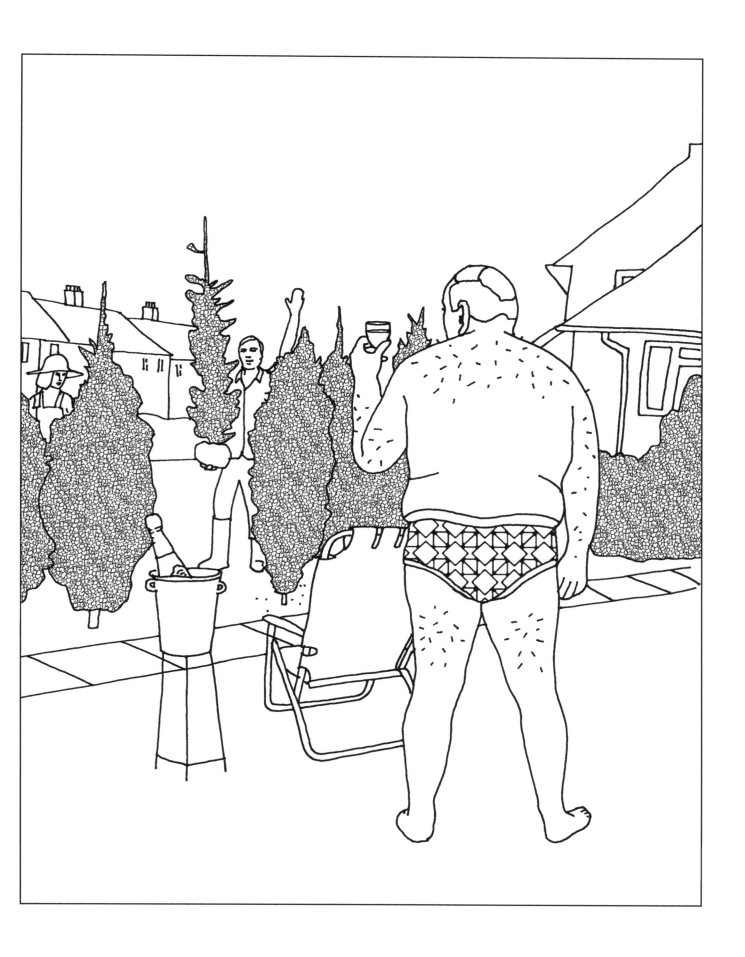

I am sunbathing in my underpants, despite my neighbours asking me not to on several occasions.

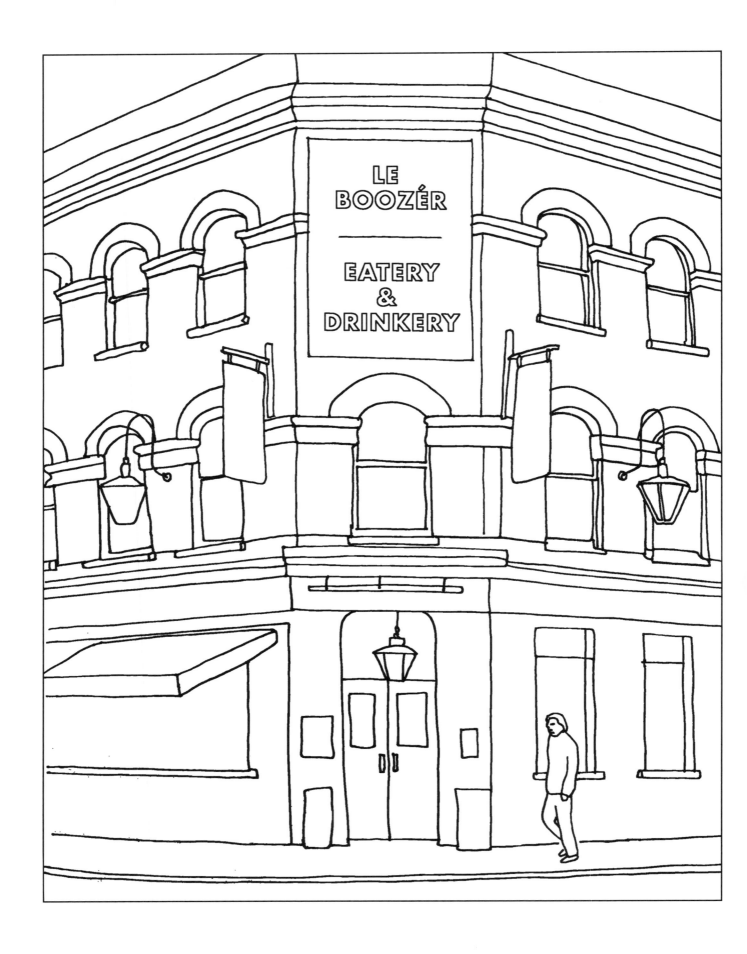

Time for a late afternoon drink. If I get tanked up now, I don't drink so much later on.

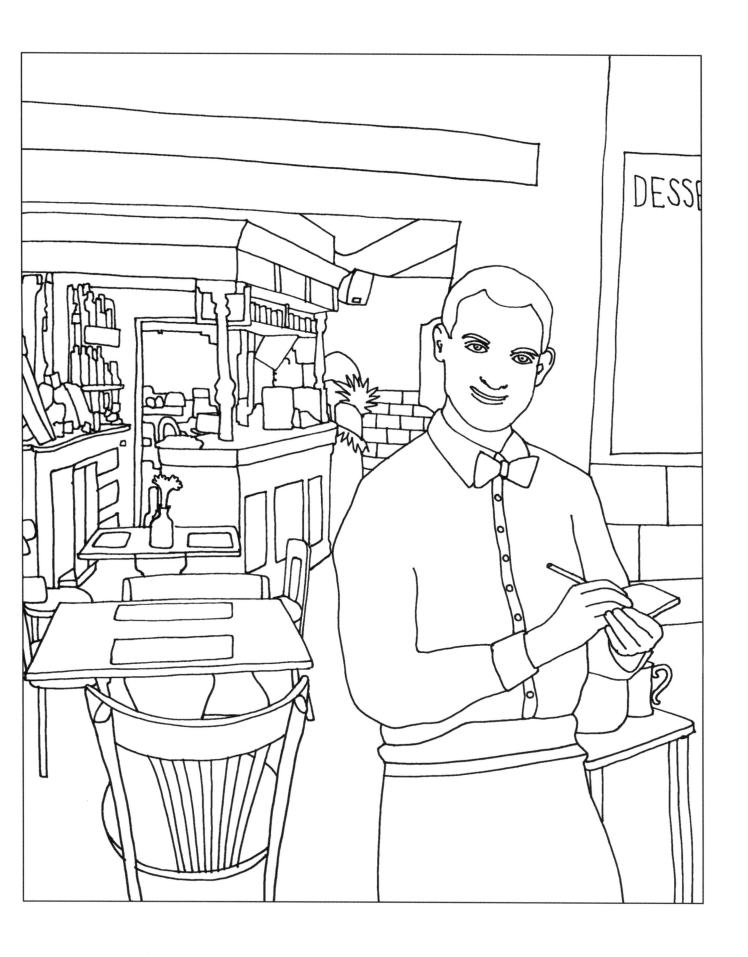

'Hi, have you booked a table, Sir?'
'I don't want a table, I want a pint of lager.'

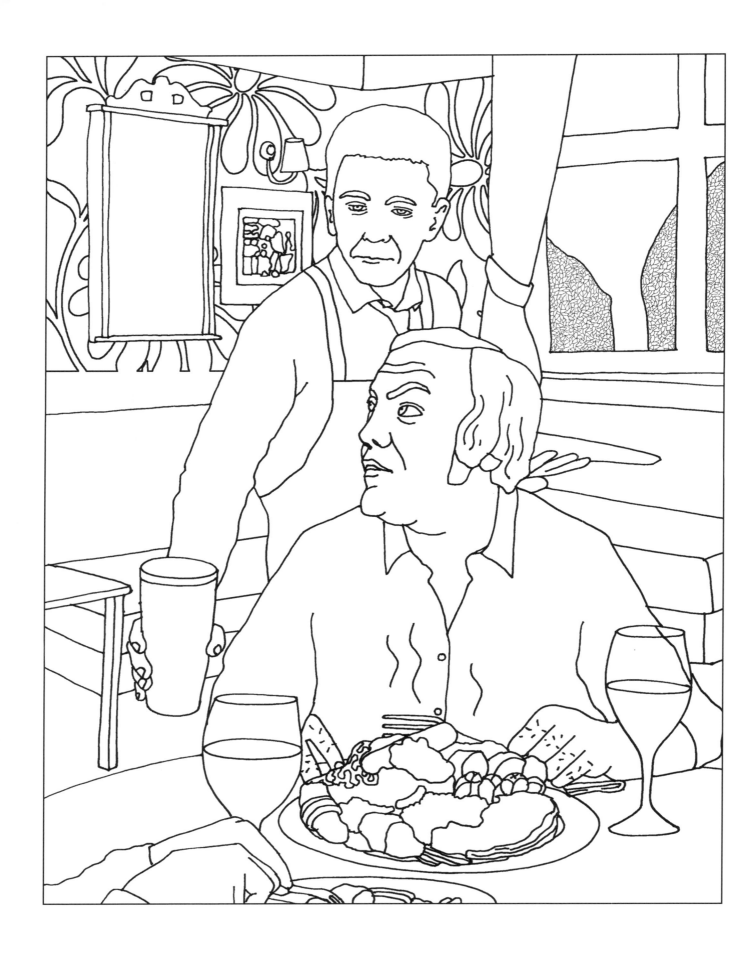

'Where's your toilet? I need to free up some colon space
before I start packing me guts out with this roast dinner.'

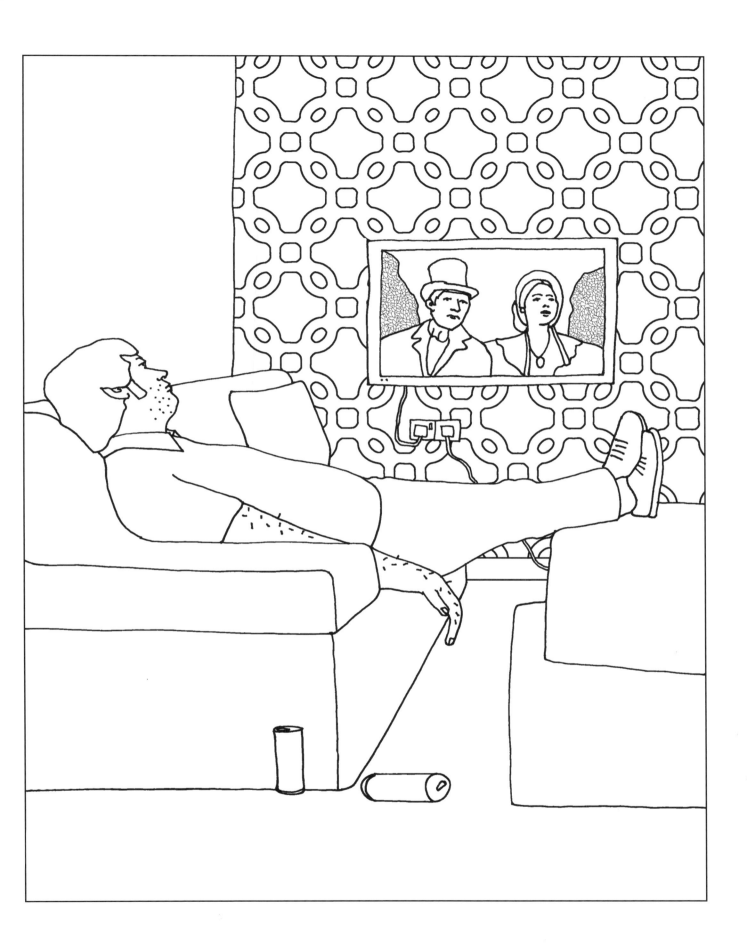

I'm too fucked to get the TV controls, so I'm just going to have to sit through this Sunday night costume drama.

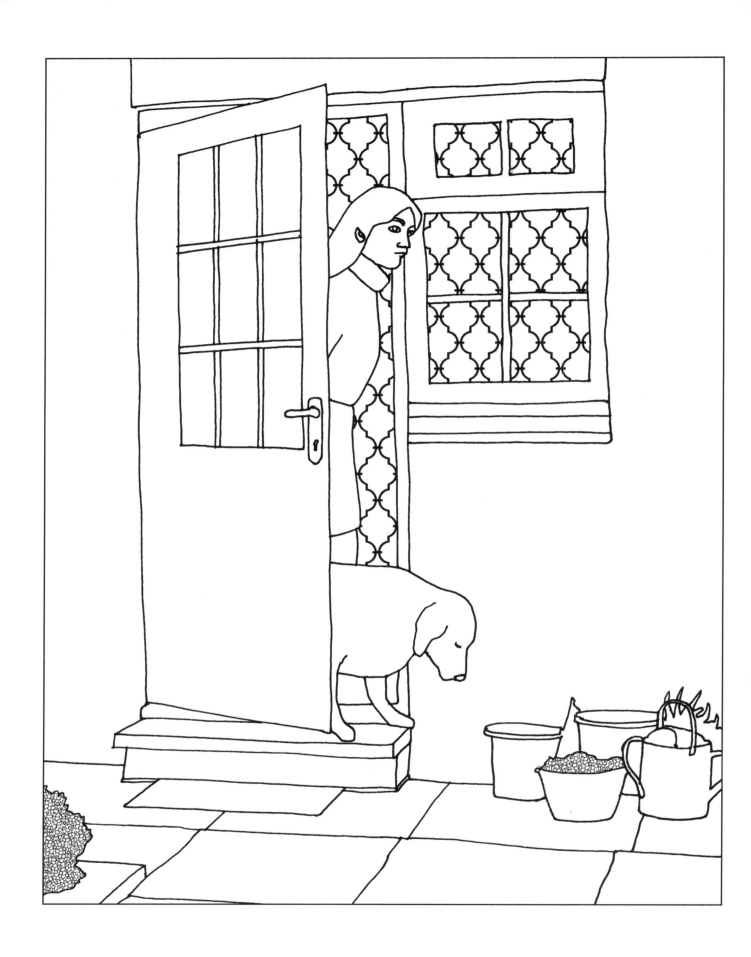

Letting the dog out for a late night Sunday piss signals the end of the weekend.

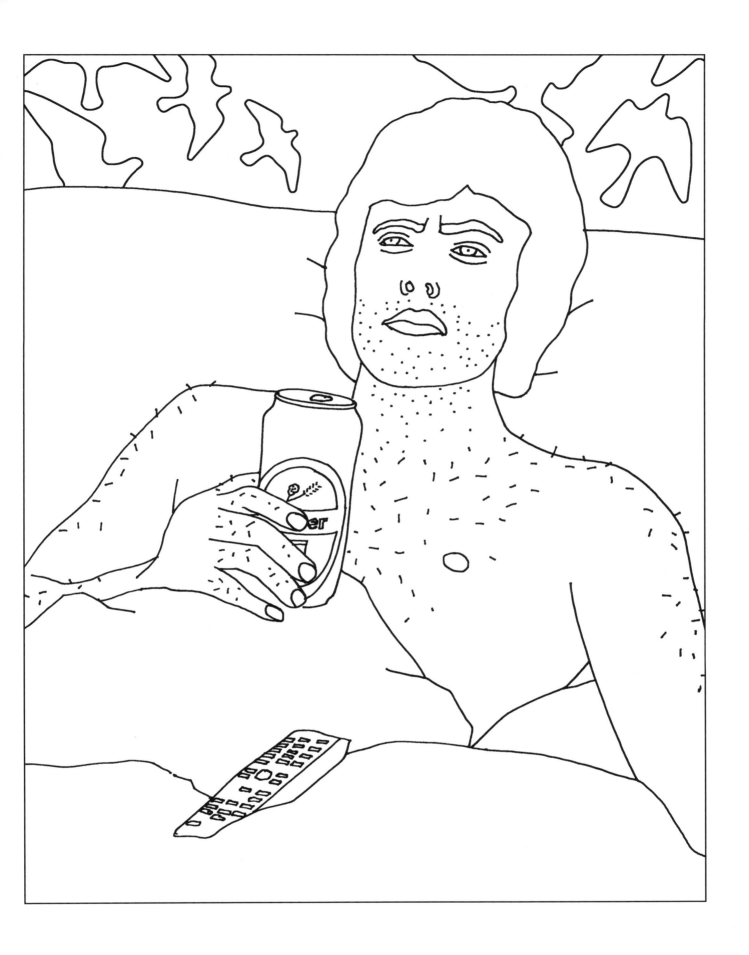

Fully replenished from the weekend, I am ready to face whatever the coming week will lob in my direction.